Squeak Carnwath

Lists,

Observations

& Counting

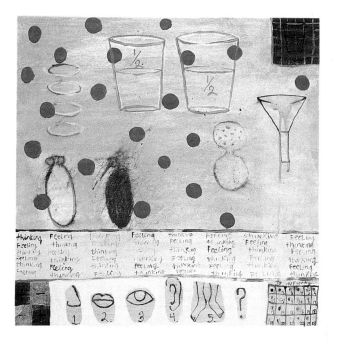

CHRONICLE BOOKS

San Francisco

Merry Christmas
Margaret,

I know you do
more printmaking
than painting,
but these works
made me think
of some of
your stuff. In
any case I hope
you enjoy them.

Dave

I0642828

All photographs by M. Lee Fatherree, Oakland, California, with the exception of **Attachments** (page 76) by E.G. Schempf, Kansas City, Missouri; **Worries** (page 32); and **Feet in Window** (page 81) by John White, San Francisco, California.

Printed in Hong Kong.

Book and cover design: Gretchen Scoble

Library of Congress Cataloging-in-Publication Data:
Carnwath, Squeak.
 Squeak Carnwath.
 p. cm.
 ISBN 0-8118-1220-0. — ISBN 0-8118-1171-9 (pbk.)
 1. Carnwath, Squeak—Catalogs. 2. Carnwath, Squeak—Philosophy
 I. Title.
 ND237.C2815A4 1996
 759.13—dc20 95-23315
 CIP

Distributed in Canada by Raincoast Books
8680 Cambie Street
Vancouver, B.C. V6P 6M9

10 9 8 7 6 5 4 3 2 1

Chronicle Books
275 Fifth Sreet
San Francisco, CA 94103

Chronicle Books® is registered in the US Patent and Trademark Office.

title page: **Counting Thinking Feeling.** 1994. Oil and alkyd on board, 15 x 15 inches.
dedication page: **The Greater Part of the Night.** 1991. Oil and alkyd on canvas, 82 x 82 inches. [Private collection]

contents

For Gary, my best friend and partner for over twenty-five years, whose exceptional patience and unconditional acceptance of my phantom lover, art, have been extraordinary gifts of love.

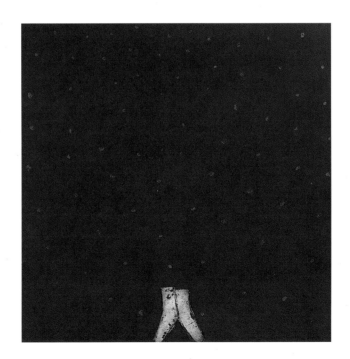

foreword

[Leah Levy]

Squeak Carnwath: Transformations

Squeak Carnwath utilizes both metaphor and depiction to express her consciousness of life in its primary forms. Acting as a contemporary alchemist, Carnwath, through her art, transforms objects and events of the everyday into symbols of the universal and the spiritual.

Her process is that of both scientist and poet-scribe: experiencing, observing, absorbing, and then recording in her work—often in great detail—the process of examination and the expression of experience. Involving both the tangible and intangible realities that alchemy suggests, Carnwath's paintings, drawings, prints, and sculptured objects are formed with a private vocabulary of routine images, one that suggests the eminently familiar while maintaining the detachment of indicators and clues.

The subjects of Carnwath's work are the simple intimacies and subtle intricacies of life: modest objects that portend significance; the interrelationships of humans and other living beings; emotions and perceptions; and the element of time itself. In its exploration, Carnwath's art emphasizes the way our lives are organized in and about daily minutia that tend to echo a broader envisioning of space and time. The particular and the generalized, the personal and the universal are equal in importance in her work.

This coming to terms with the ineffability of life, of making peace with organic rhythms through a measuring and counting of life's infinite parts, can be placed within the context of the work of other twentieth-century artists whose philosophical approaches are linked with Carnwath's. Abstractionists like Piet Mondrian and Agnes Martin use essentially nonobjective expression to depict and recreate their unique perceptions of a universal order. In similar ways, the geometry and repetition in Carnwath's work function to emulate a patterning in nature, from the grand celestial systems to the most intimate ones, such as a beating heart.

Representations of the ordinary that persist as the themes of Carnwath's work are also part of an historical "interior" continuum in the manner of French painters Pierre Bonnard and Edouard Vuillard, for example, who honored home life in their exquisite paintings of routine activities.

Carnwath's work also contains an intellectual affinity with certain conceptual artists, who, in the tradition of Marcel Duchamp, elevate a quotidian object or action to the realm of art by the decision of consciously observing and isolating it. In this sense, Carnwath's practice of listing and naming items, conditions, and experiences distinguishes them as outside of the regular and imbues them with a meaning we then decode through our own personal associations.

In her number writing, as well as in the metering out of letters into ultimate words and messages, Carnwath shares her understanding of time by revealing it directly. The systems of marking time echo the progression that her overview of life engenders: the moments to make, mark, and then read a symbol (number, letter, word, icon) and the commemoration of the varied rhythms of lives lived in time. The simplicity of Carnwath's vernacular belies a more typical idea of mysteries as unfathomable. In the confrontational directness of her work, the artist offers a depiction of the process of her self-education and reeducation, tracking the challenges both in life and in paint. She has a willingness to review the discourse (whether allegorical or actual) until she makes it right with herself, using repetitive emphasis as a tool in claiming the information as her own.

The surfaces of Carnwath's paintings reflect this careful working and reworking, this sensuous attention to the matter of things. While they may appear flat at first viewing, with time each work reveals an intricacy of texture, stroke, and tone. No color is true or solid: seemingly large monochromatic areas are either composed of an array of commingled colors or, as is often the case with black, a layering of different consistencies of the same or similar paints. The lines and textures of each work are employed as yet another way to indicate the place of contact, the marking of a moment with a line, the vibrancy of the process of touching caught and recorded.

Ultimately, a unique combination of clarity and mysterious beauty constitutes the substance of Carnwath's art. Throughout her oeuvre, she portrays a confluence of form, gesture, symbol, and diaristic revelation in the essence of her mark.

Artist working on a small painting, 1995.

preface

[Squeak Carnwath]

Reflections on the Recognition of Making, Untold Recollections, and Other Random Notes

Recently, I found my school report cards. It's true. I was a bad child, an even poorer student. When I was a girl, being good brought no entitlement, no privileges. A girl was still a girl. Good or bad. What to another child might have appeared to be a closed door presented to me an enormous possibility: A chance to do what I wanted. To become an artist.

■

I decided that when someone asks me where I'm from, I will say Marblehead, Massachusetts. And, although I didn't grow up there or live there long, Marblehead was my space. I still had my dog then, and we used to bicycle all over town together. She running alongside of me. Marblehead was a great town to explore. I could see and imagine anything.

Some days I'd go to the rocks by the ocean and, when the tide was out, I'd walk to the island out there. Other days I'd go watch the fishermen bring in lobsters. The town was full of very old houses, and I loved all that Yankee tradition. I remember making a treasure map once—actually more than once. I worked on them for hours, using India ink and dipping the paper in tea and then carefully burning the edges for that "old" effect. I usually did all of this under my bed and one day I set my bed on fire, but no one ever found out because I quickly put the flames out.

I would take my maps and hide them. One of the best and most authentic places I chose was an old stone wall. It had to have been built during Paul Revere's time. I took a few of the rocks out of the wall, put my map in, and put the rocks back in their places. I still wonder if anyone found my treasure map there.

It was in Marblehead that I met a wonderful artist. I was most inspired by him. His house was built on a great big rock in the middle of town. I had to climb a lot of steps to get to his front door. He was from

Holland or Sweden, I can't remember which, and he had a very soothing soft accent. He talked my parents into letting me come sit for him for a portrait. I love that portrait still today. He got something into it that I have since lost.

He knew that I wanted to be an artist, so he told my parents about this little art school in town where I could go. Basically, he convinced them for me. Now this art class was really dumb but a lot of fun for me. My dog and I would go three or four nights a week. Me, the only kid, her, the only dog. The rest of the students were little old ladies and one or two men. The great thing about the place was that, aside from the studio classroom, there was an art supply shop, which is where the guy who ran the place made his money. I loved the supplies and I could charge to my father anything I needed for the class. The more paintings I did the more supplies I could charge. I enjoyed greatly the pleasure of picking out more colors and different sized brushes. The tools were as much fun as the actual painting. In class, we would sit around and paint. There were no models, no still lifes set up; instead, the teacher had a huge collection of pictures from calendars laid out on a big table, and we were supposed to rifle through these for the subjects of our paintings. Even at age nine I knew that this method of art was pretty silly. But it was fun. The little old ladies thought I was cute and they loved my dog.

FROM **The I Stories**, 1975

■

We live in complex times. The speed with which we receive information has created doubt about the nature of truth. We have an increased sensitivity to the social construction of reality. We live in a world where we no longer experience a secure sense of self. Expressions of mystery are difficult to believe. The world's chaos gets into our houses, delivered live to us by television, radio, phone, and fax.

Television creates the phenomenon of self-multiplication, the capacity to be significantly present in more than one place at a time. Much of what we do is a product of our narcissistic culture. We are encouraged to create a false self, one that can quickly be understood or apprehended like so many images on a television screen. Quickness—fastness—keeps us in denial and takes us out of our bodies. The dilemma of disassociation is relieved by art's capacity to put us inside our skin in real time. Art is the antidote that reminds us to breathe, to feel the soles of our feet and the touch of the ground on the bottom of our toes.

FROM A TALK GIVEN AT **California College of Arts and Crafts**, 1993

A Simple List

1. It's simple really,
 to paint is to trust.
 To believe in our instincts; to become.

2. Painting is an investigation of being.

3. It is not the job of art to mirror. Images reflected in a mirror appear to us in reverse. An artist's responsibility is to reveal consciousness; to produce a human document.

4. Painting is an act of devotion. A practiced witnessing of the human spirit.

5. Paintings are about:
 paint
 observation &
 thought.

6. Art is not about facts but about what is; the am-ness of things.

7. All paintings share a connection with all other paintings.

8. Art is evidence. Evidence of breathing in and breathing out; proof of human majesty.

9. Painting places us. Painting puts us in real time. The time in which we inhabit our bodies.

10. Light is the true home of painting.

11. The visible is how we orient ourselves. It remains our principal source of information about the world. Painting reminds us of what is absent. What we don't see anymore.

12. Painting is not only a mnemonic device employed to remember events in our lifetime. Paintings address a greater memory. A memory less topical, one less provincial than the geography of our currently occupied body. Painting reminds us of what we don't know but what we recognize as familiar.

13. Painting, like water, takes any form. Paint is a film of pigment on a plane. It is not real in the way that gravity-bound sculpture is real. It is, however, real. Painting comes to reality through illusion. An illusion that allows us to make a leap of faith; to believe. To believe in a blue that can be the wing of a bug or a thought. It makes our invisible visible.

■

Lists, observations, and counting are modes of thought that occur frequently in my paintings.

Artist working on a drawing, 1985

introduction

[Ramsay Bell Breslin and James E. B. Breslin]

Working in the Dark

At a slide presentation Squeak Carnwath gave of her works at the San Francisco Art Institute in April of 1995, the painter spoke to her audience in a deep, fluid voice while standing in complete darkness. "I like to work in the dark, both metaphorically and literally," she joked. She then played a taped excerpt from *The I Stories*, recorded in 1975, her first year of graduate school. Riveting the audience with her then high, clear, trance-like voice, Carnwath tells how, as a child, she used to lay in bed at night projecting a black and grey "texture-smooth space" onto her bedroom ceiling.

Experiencing this space with her whole body, she felt excited and sometimes frightened; she would then control the space so that it didn't overwhelm her by covering the entire ceiling with a black, then white, lower case *a*. By slowly reducing the size of the *a* until it disappeared, she could also retrieve the space and re-experience its shifting textures: "It was like a rock, that feeling, and like floating water, too." At age five, Carnwath was already working in the dark.

Yet many of Carnwath's paintings radiate light. **Inside Thought** (page 98) is so bright it almost makes one back away. Superimposed on its brilliant yellow ground, the grey outline of a gigantic head, with handles for ears and a triangular top (with knob) for a crown, comically doubles as a kitchen jar: a container for thoughts or everyday objects. Filling the triangle, a crowd of spongy white Buddhas look stamped on, but also disembodied—divine spirits barely contained within a temple (!) of enlightened thought. Below the brain, inside the cup-shaped face, three rows of isolated objects—among them a diamond, a perpetual hourglass, a bird, and a house—appear suffused in a white, otherworldly light, existing within the meaty yellow ground that expands to the edges of the canvas. Despite the head's wide, schematic border (a bold attempt to unify, separate, and contain the pictographs), some images seep out beneath its painted outline, as if containers could not, after all, contain.

Outside the head, rows of numbers painted red, and mostly in reverse, fill the remaining canvas. By writing the numerals 1 through 75 backward, Carnwath encompasses the movement of time, a lifespan. "It is not the job of art to mirror," says Carnwath. "An artist's responsibility is to reveal consciousness." By reversing the numbers, Carnwath rejects the notion of art as a passive mimesis by placing herself behind the picture plane, inscribing the years of her life (her own age, 47, is circled) onto a canvas she imagines as a body from the inside out. The consciousness revealed is at once universal and personal, spiritual and physical, a floating Buddha *and* a bounded body.

Inside a head, outside of time, certain familiar shapes persist; they just *are*, reappearing in painting after painting, as if to ward off their loss, yet taking on shifting identities, so that the perpetual hourglass in **Inside Thought** becomes the figure eight–shaped swarm of bees in **Day Song** (page 49). Like people or buildings viewed from a distance, Carnwath's constant shapes present themselves to be recognized and then named. Rather than delineating objects, their glowing outlines present a state of being assuming (temporarily) an identity.

In **Inside Thought**, as elsewhere, these objects, suspended in multiple layers of translucent paint and connected by dotted lines that both join and separate, manifest a human consciousness that exists both independently and in relation. In Carnwath's work, intimacy comes not from proximate relations between entities (a bird nudging a house) but rather from a light that permeates simple objects (a bird, a house) while preserving their distance.

In general, however, her paintings collapse distinctions: by intermingling upper- and lowercase letters, by combining cursive and printing in which letters are both linked and detached. By counting colors and numbers and by making lists of words and rows of objects, Carnwath creates visual screens through which layers of meaning and feeling push forward toward the viewer as buried images and words surface from her painterly depths into a single picture plane. "I want painting to be my flashlight," says Carnwath.

But what we see when she shines her painter's light looks like frozen sunlight: thin, transparent layers of color riddled with cracks, scratches, and veins that have been smoothed flat with a palette knife. By collapsing textural distinctions, Carnwath dispenses with figure-ground tensions. Instead, diagrammatic relations and images of containment give way to an all-encompassing light that defines objects by making them barely distinguishable from their grounds. This pull toward unity is evident in all of Carnwath's work. The Buddhas flooding

the brain of **Inside Thought** playfully evoke the oneness at the heart of pure being. Yet the consciousness of this painter, in rendering the vaunted human mind as an anonymous cartoon icon and imagining mystical unity with a *multiplicity* of Buddhas, combines the philosophical with the playful.

Carnwath also introduces doubt, humility, and anxiety into her quest. One deep source of this anxiety (expressed elsewhere as multiple black crosses, swarms of bees, or a column of skeletal handprints shaped to resemble a spine) appears in **Memory** (page 67), a thunderous black and red painting that powerfully conveys both the awe and fear of death.

"The Memory / of sleep / comes over / us we hope / please / just another day." This lone human cry or prayer, brushed in red on a dark ground, forms a kind of emotional base for a small black and white square suspended at the center of a black and red striped ground. Subdivided into three smaller squares, this larger square resembles a window spanning the top half of a double doorway, creating the illusion or the possibility of depth, vision, or access to a world beyond our sight or life span: a stark, anonymous, and enigmatic world of pure black and luminous white. Together the mysterious square and the anxious words dramatize a vulnerable human presence—Carnwath has spoken of "the fragility of being"—but a presence that can withstand the grim emotional force embodied in the repeated bold red and black horizontal stripes that dominate the painting and evoke, in Wagnerian chords, our common end: non-being.

Even here, however, Carnwath retains her sense of humor. Inside each of four hypnotic ocher-yellow squares, suspended just below each of the painting's corners, are silhouettes of black socks, in profile, all facing the same direction. In life, socks protect feet; they are the last things we take off at night before going to bed. In **Memory**, they become playful memento mori or wryly imagined bodyguards, stern and erect (though empty), safeguarding the human spirit.

In *The I Stories*, Carnwath tells us that the pieces of furniture in her childhood room "all had bands of colored light around them" and that the furniture moved. In **Attachments** (page 76) three stacked squares, with thick, glowing purple borders, form a pyramid of light-filled chambers, each holding a familiar object—a glass, a bird, a pair of feet—that neither floats nor appears embedded in its luminous ground. The squares' feathery edges make the light inside them look slightly rounded, separate from their parameters, self-contained. Yet, because the

[above] Artist with horse and brush, 1995.
[below] Artist behind horse, 1995.

borders are both hard-edged and diffuse, the firmness of the contours depends upon which aspect of them you focus on. When seen as diffuse, the edges shift the pyramid's locus of stability from its strict outlines to the light inside — a transformation suggesting that true solidity is internal and spiritual, rather than structural.

The pyramid also resembles a kind of schematic human body, detached (and free) within itself and from the world. From a distance it seems to sit in a calm radiance; up close the paint looks turbulent, as if scratched by wind-blown branches. After prolonged looking, however, a deeper, more paradoxical meaning emerges: true steadiness is the expression of constant motion between the inside and the outside.

Outside the pyramid, dense, undulating rows of black handprints fill the canvas with conflicting human feelings. They look happy, touching one another, pairing up, but they are also slightly scary, resembling X-ray images of hands, hands with holes in their palms that look like they have been pressed to the canvas to assure the artist that she is there, that she is.

Yet the handprints threaten to overwhelm the canvas with a physical sensation and movement that no longer exists, just as the words urging physical pleasure, "Love to taste / Love to see / Love to touch," have been obscured by the physical activity of the hands. It's as if the artist, *this* artist, combines a core of pure being, luminous and self-contained, with a human identity that is continually struggling to be there, always leaving its mark, always absent, having just been there.

THE FRAGILITY OF BEING

EELING IN THE DARK

lists

SOURCES OF

GHT IN THE NIGHT

NDLES SINGING FLARES
HTNING BUGS MOON HEAVEN
ARS WATER LOVE
ES MOVIES SPARKLETS
ADLIGHTS FLASH BULBS FIRE

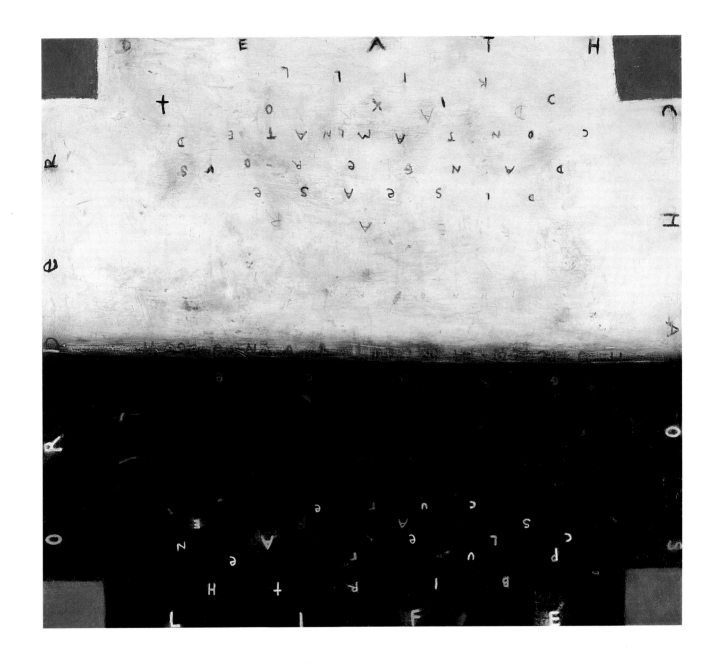

Boundaries. 1987. Oil and alkyd on canvas, 82 x 92 inches. [Collection of Art Berliner, San Francisco, California]

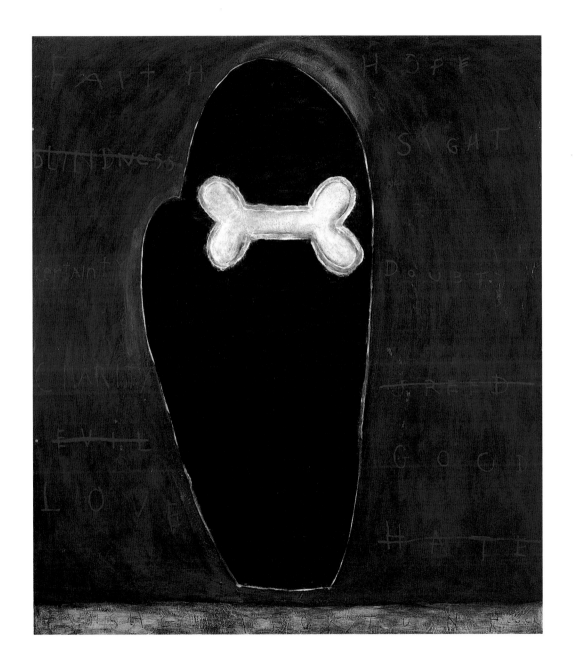

In (the Baby's Picture), **1987**. Oil, alkyd, and wax on canvas, 84 x 74 inches. [Collection of Richard Nagler and Sheila Sosnow, Piedmont, California]

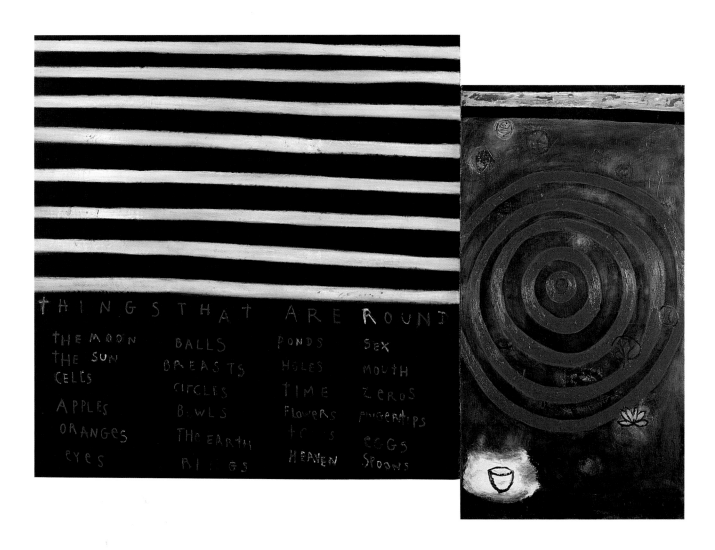

THINGS THAT ARE ROUND

THE MOON BALLS PONDS SEX
THE SUN BREASTS HOLES MOUTH
CELLS CIRCLES TIME ZEROS
APPLES BOWLS FLOWERS FINGERTIPS
ORANGES THE EARTH TCS EGGS
EYES RINGS HEAVEN SPOONS

Planets. 1988. Oil and alkyd on canvas, 92 x 124-1/2 inches (two panels). [Collection of Jonathan and Nancy Goodson, Los Angeles, California]

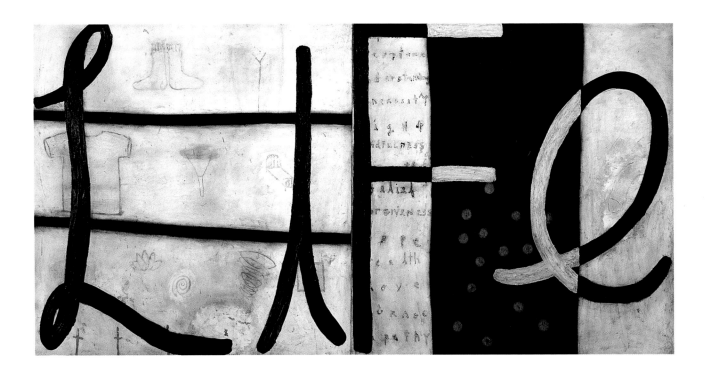

Homework, 1989. Oil and alkyd on canvas, 77 x 154 inches (two panels). [Collection of Richard and Roselyne Swig, San Francisco, California]

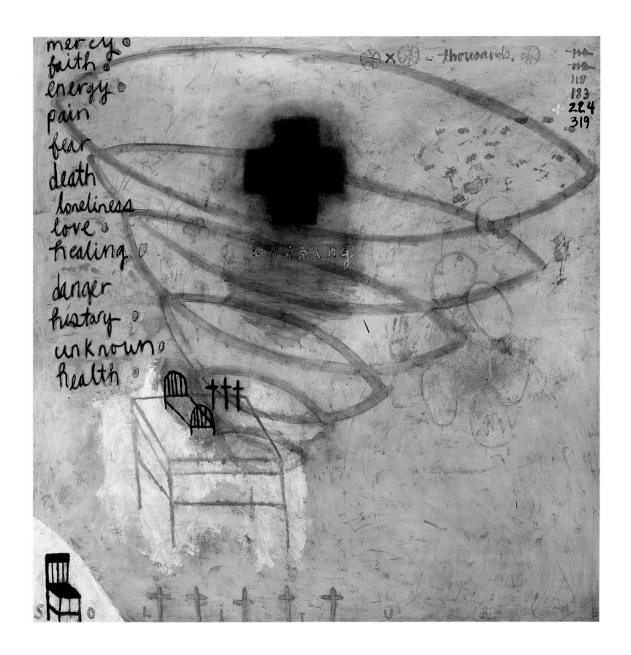

Grace. 1989. Oil and alkyd on canvas, 77 x 77 inches. [Private collection, San Francisco, California]

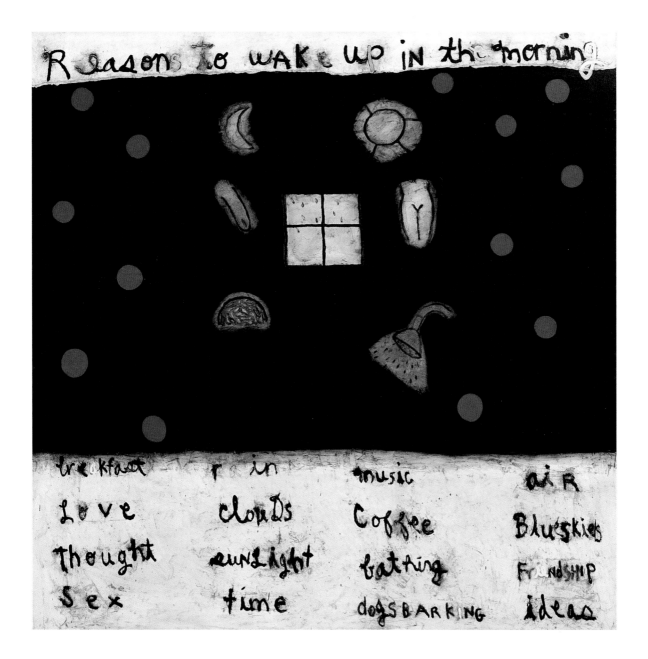

Reasons. 1991. Oil and alkyd on canvas, 82 x 82 inches. [Persis Collection, Honolulu, Hawaii]

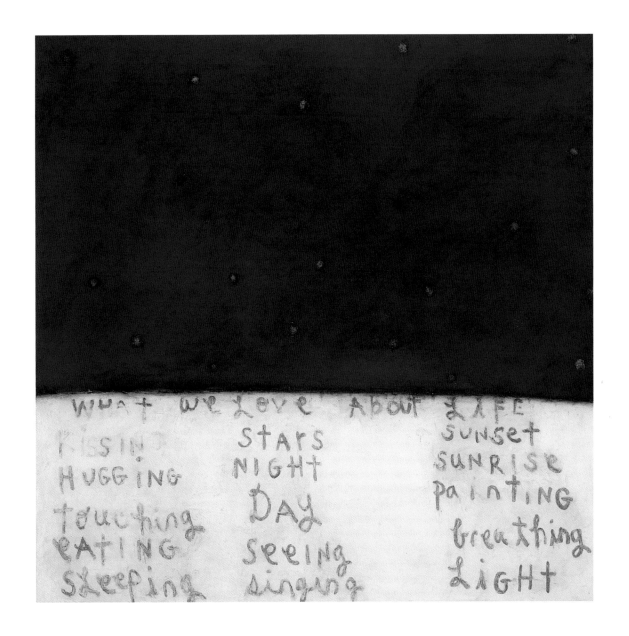

Heaven. 1991. Oil and alkyd on canvas, 82 x 82 inches. [Barbara and David Hancock Collection, Los Angeles, California]

Skin, Flesh and Blood. 1993. Oil and alkyd on canvas, 80 x 110 inches. [Collection of the artist]

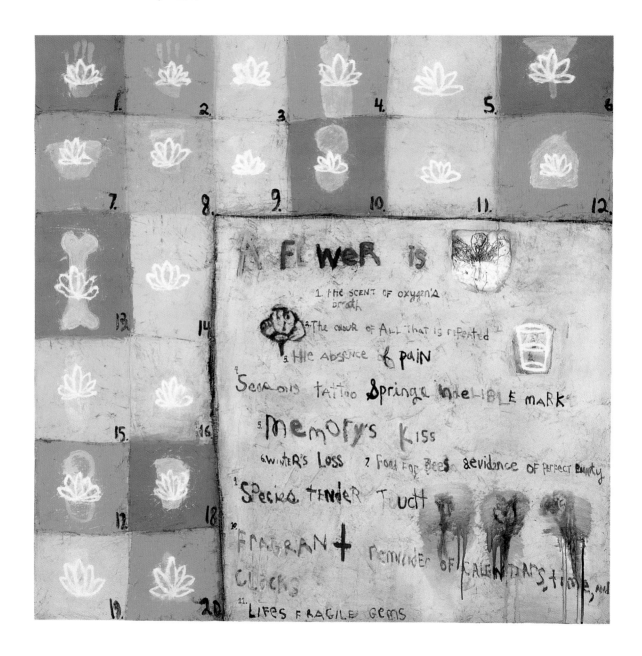

Fragile Gems. 1994. Oil and alkyd on canvas, 70 x 70 inches.

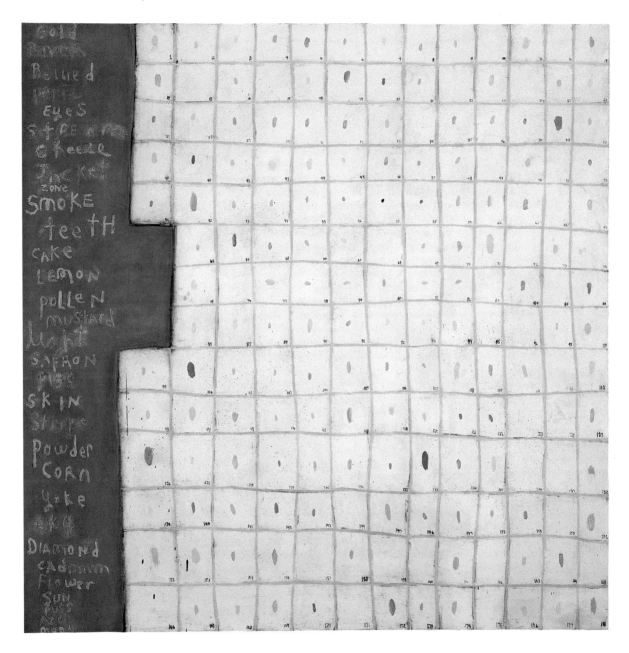

Yellow Stuff. 1995. Oil and alkyd on canvas, 82 x 82 inches. [Private collection]

What Is Red. 1994. Oil and alkyd on canvas, 80 x 80 inches. [Private collection]

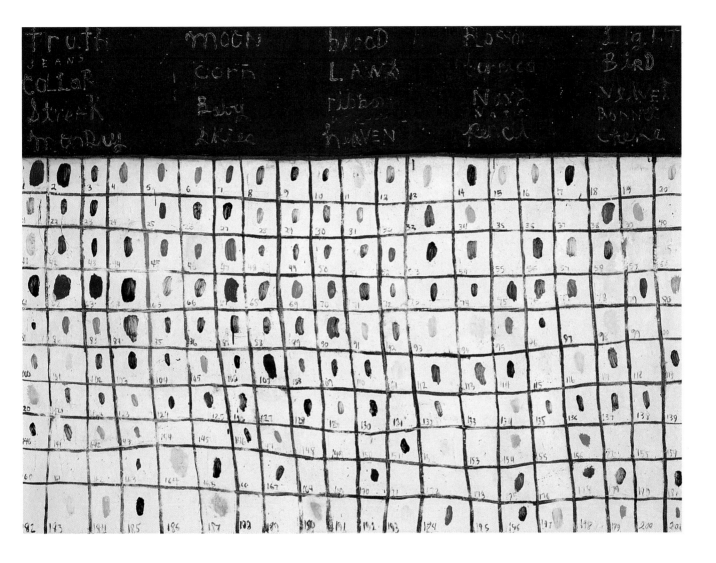

What Is Blue. 1993. Oil and alkyd on canvas, 76 x 102 inches. [Private collection]

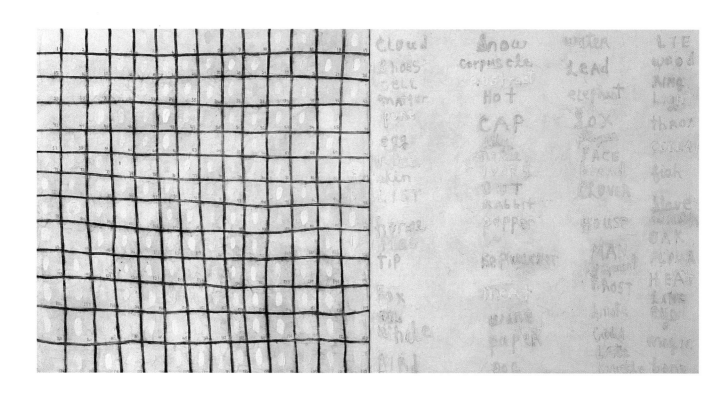

What White Is, 1994. Oil and alkyd on canvas, 80 x 160 inches (two panels). [Collection of the Oakland Museum of California, gift of the Art Guild and friends and family in memory of Anne Gray Walrod]

Black Is. 1994. Oil and alkyd on canvas, 82 x 82 inches. [Private collection, San Francisco, California]

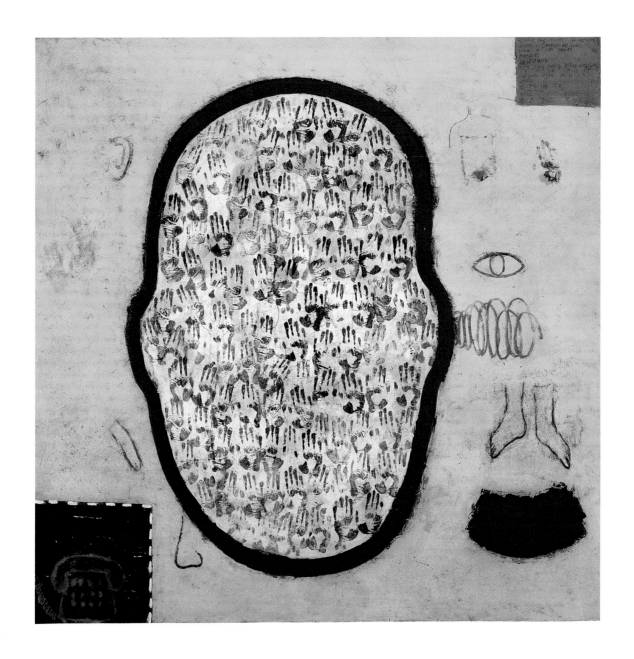

A Call to Be. 1992. Oil and alkyd on canvas, 82 x 82 inches.

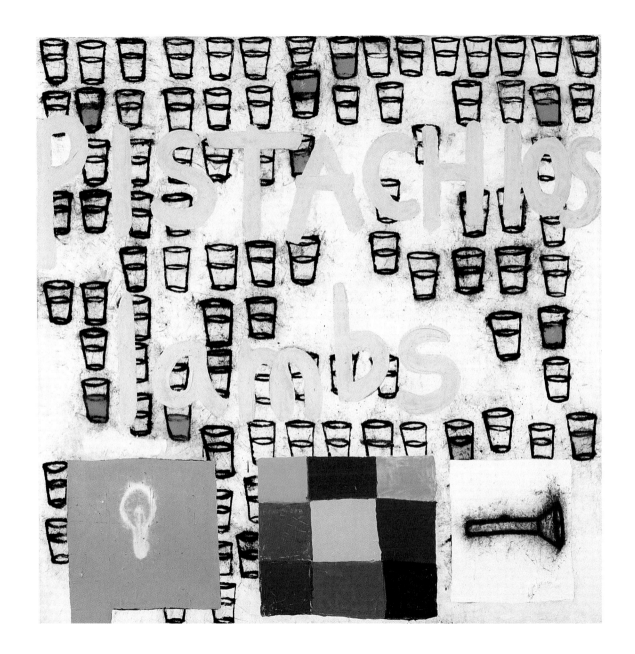

Analphabetic. 1993. Oil and alkyd on canvas, 70 x 70 inches. [Collection of Daniel and Miriam Scharf, Kansas City, Missouri]

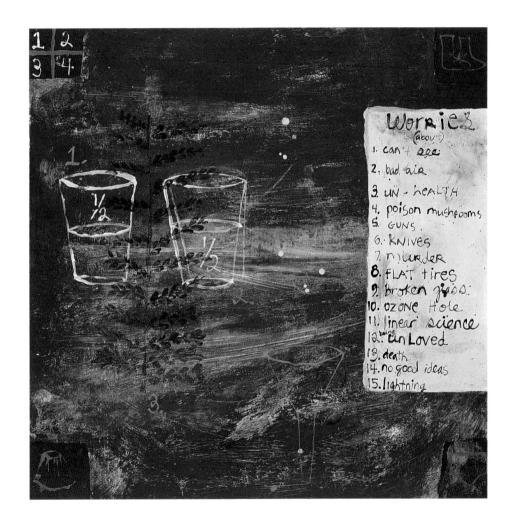

Worries. 1994. Egg tempera on birch wood, 11 x 11 inches. [Collection of Charles C. Forrester]

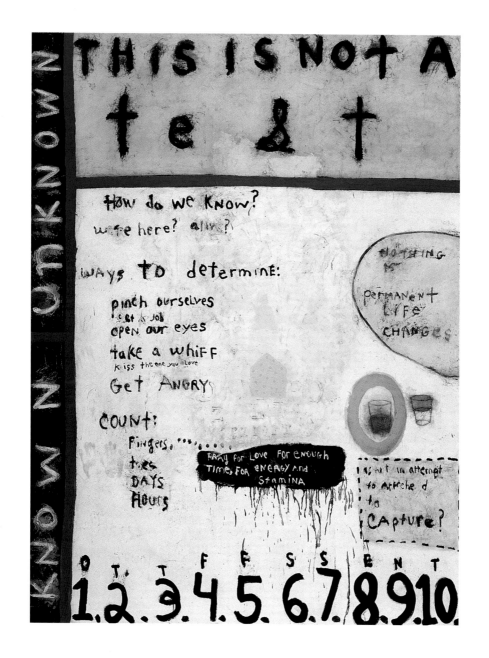

This Is Not. 1994. Oil and alkyd on canvas, 102 x 76 inches.

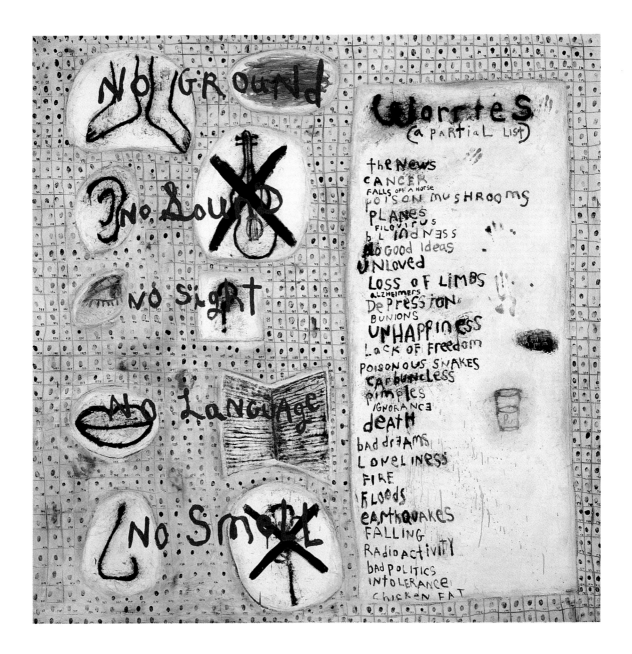

Big Worries (A Partial List), 1995. Oil and alkyd on canvas, 82 x 82 inches.

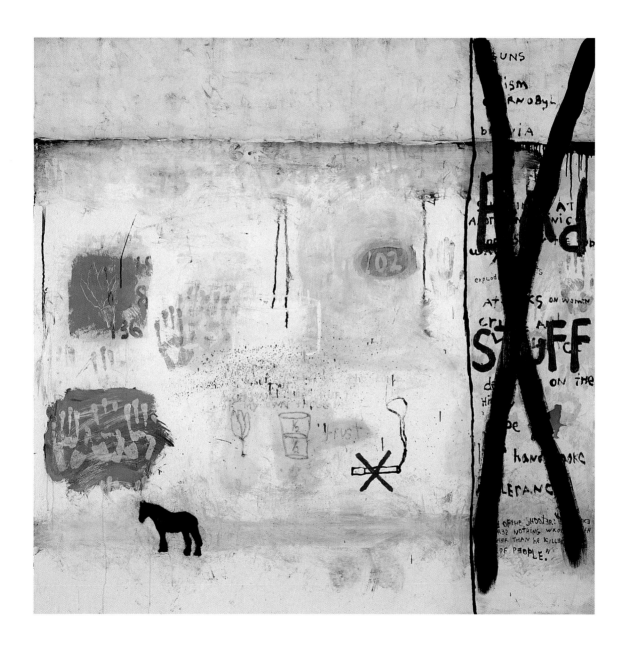

Bad Stuff, **1994**. Oil and alkyd on canvas, 60 x 60 inches.

observations

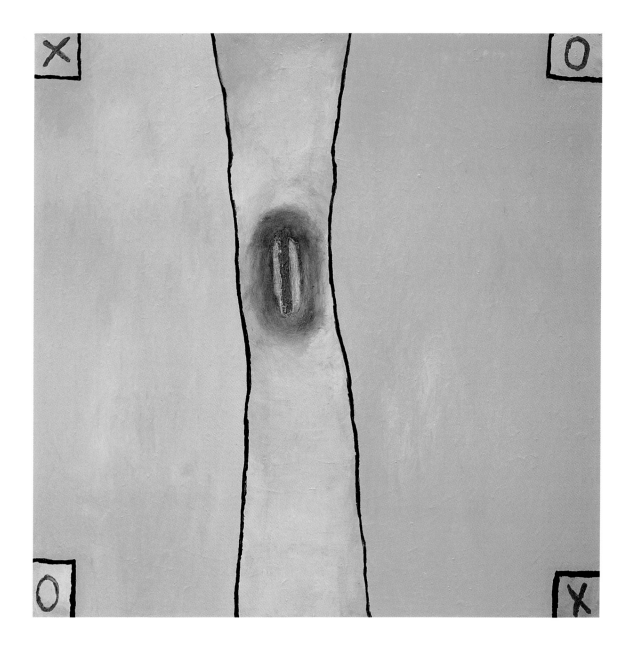

Between. 1987. Oil and alkyd on canvas, 60 x 60 inches. [Collection of Squeak Carnwath and Gary Knecht]

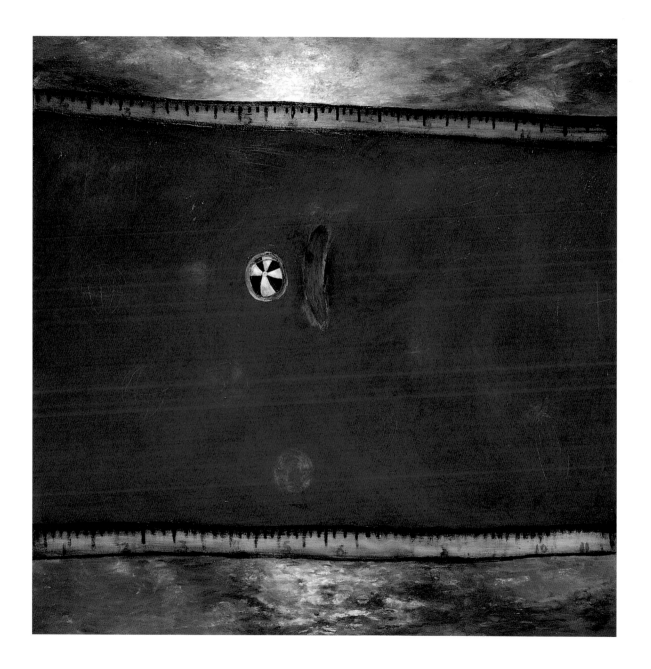

Above Below. 1987. Oil and alkyd on canvas, 60 x 60 inches. [Collection of Dan and Claire Carlevaro, San Francisco, California]

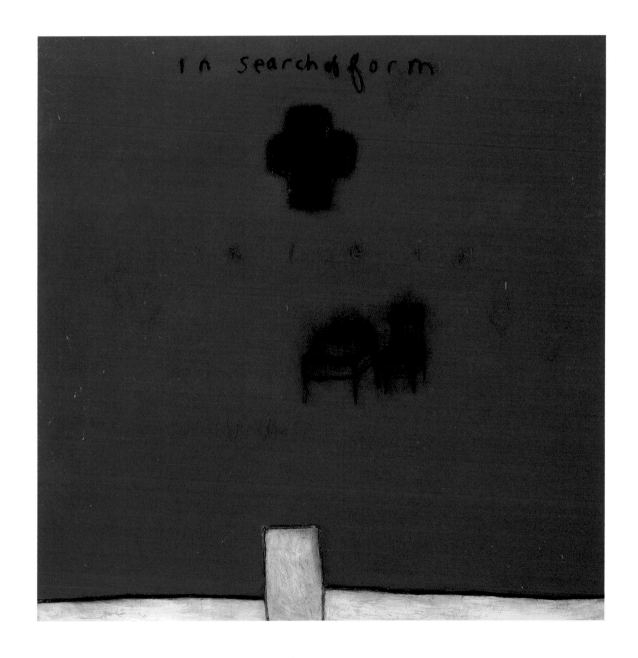

Flashback, **1988**. Oil and alkyd on canvas, 82 x 82 inches. [Collection of Agnes Bourne and Jim Luebbers, San Francisco, California]

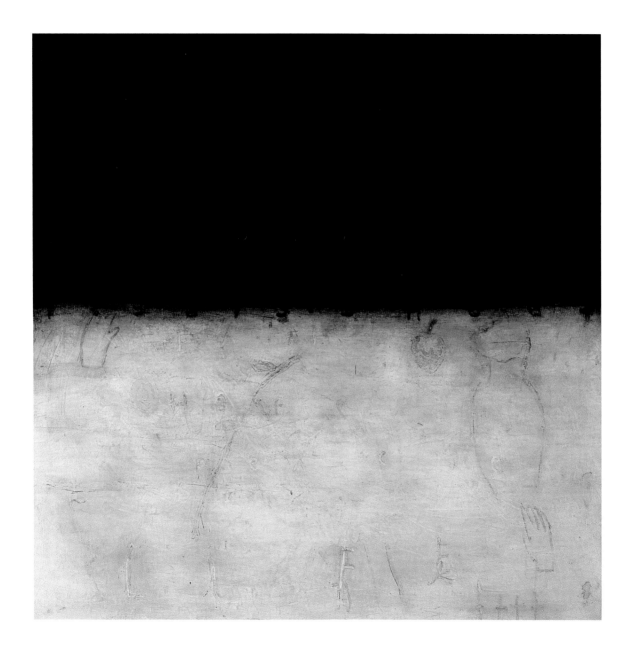

Thank You. 1988. Oil and alkyd on cotton, 70 x 70 inches. [Private collection]

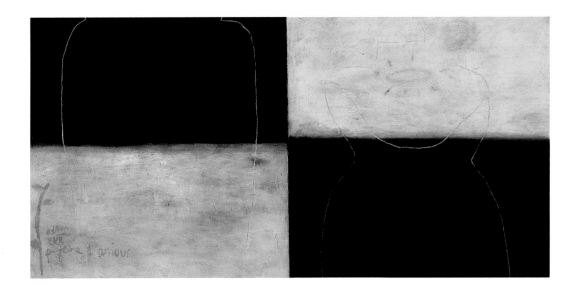

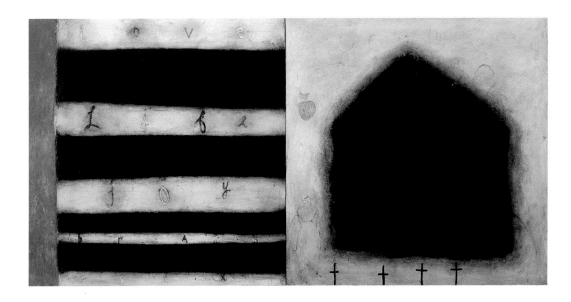

above **Innocence. 1988**. Oil and alkyd on canvas, 82 x 164-1/2 inches (two panels).
[Collection of Sally Sirkin Lewis, Beverly Hills, California]
below **The Hive. 1988**. Oil and alkyd on canvas, 70 x 140 inches. [Collection of Jill and John C. Bishop, Jr.]

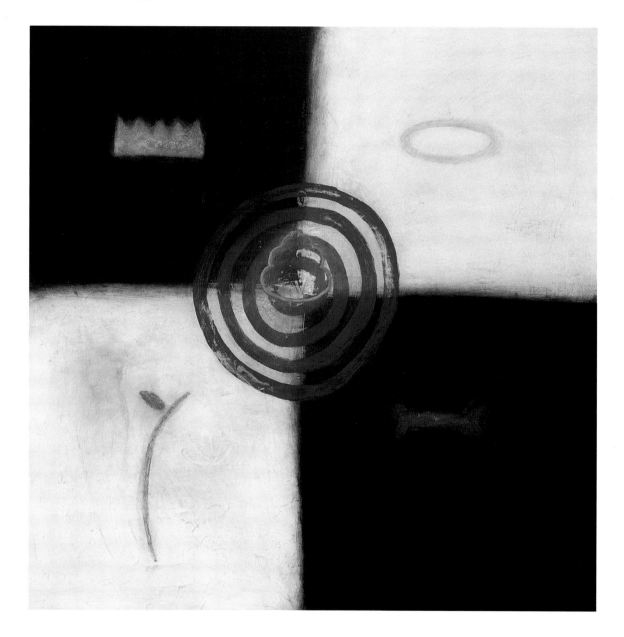

Instinct, 1988. Oil and alkyd on canvas, 60 x 60 inches. [Collection of Morris and Ellen Grabie, Los Angeles, California]

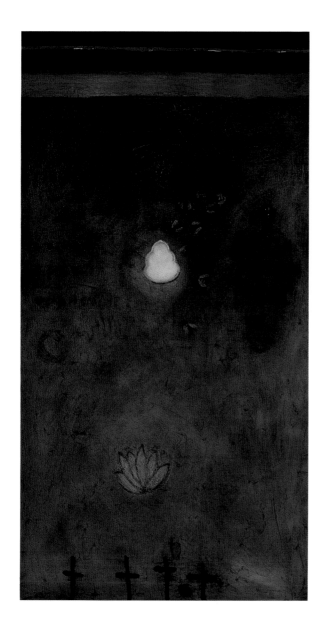

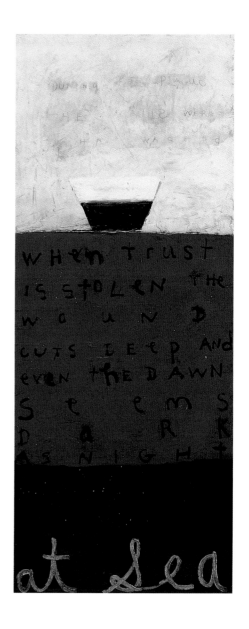

left **Trust. 1988.** Oil and alkyd on canvas, 80 x 42 inches. [Collection of Sheila and Wally Weisman]

right **Boat at Sea. 1992.** Oil and alkyd on canvas, 70 x 28 inches. [Collection of Pamela Woodbridge and Elliot Davis]

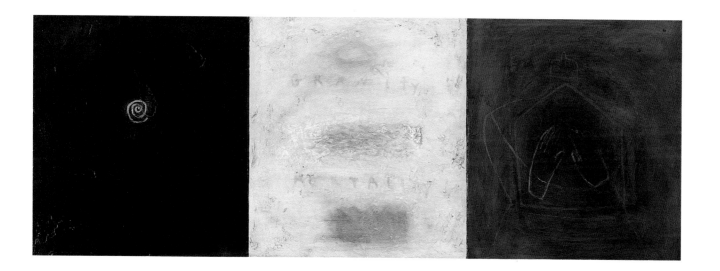

Gravity. 1988. Oil and alkyd on canvas, 32 x 87-3/4 inches (three panels). [Collection of Penelope Campbell]

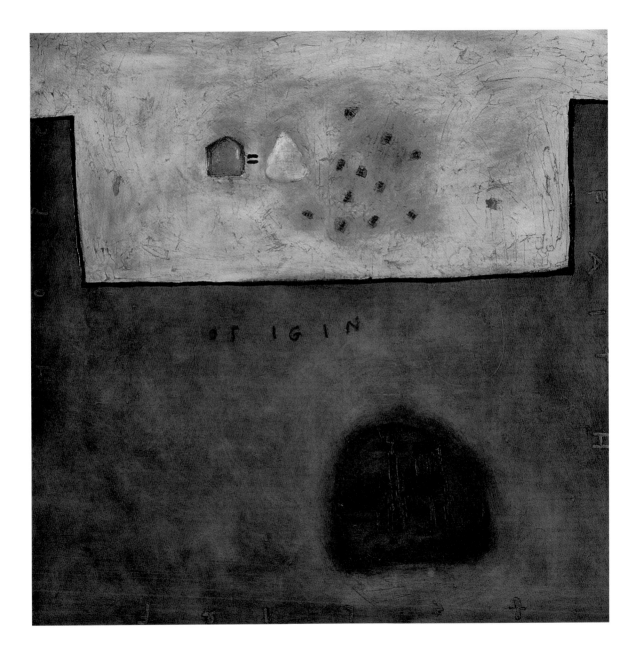

Life in the Hive, 1988. Oil and alkyd on canvas, 70 x 70 inches. [Collection of Penny Cooper and Rena Rosenwasser, Berkeley, California]

The Man in Love. 1990. Oil and alkyd on canvas, 60 x 60 inches. [Collection of Lawrence Barth, Los Angeles, California]

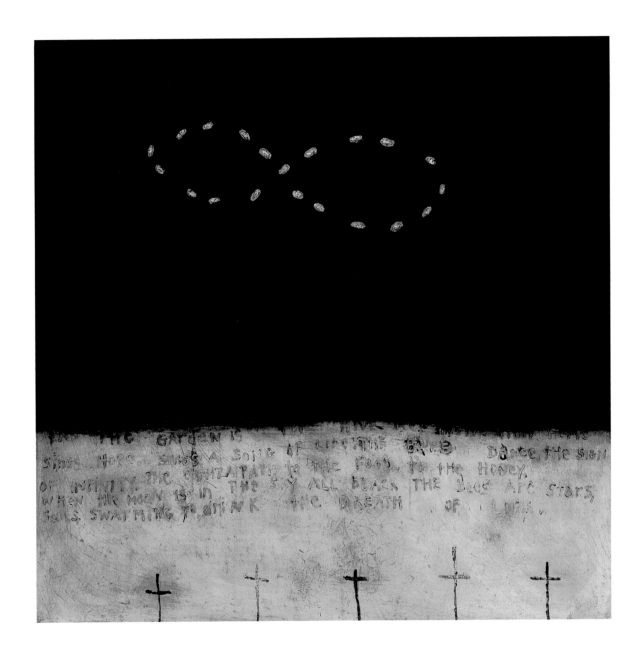

Night Song. 1988. Oil and alkyd on canvas, 82 x 82 inches. [Collection of Charlie Mitchell,
Santa Barbara, California]

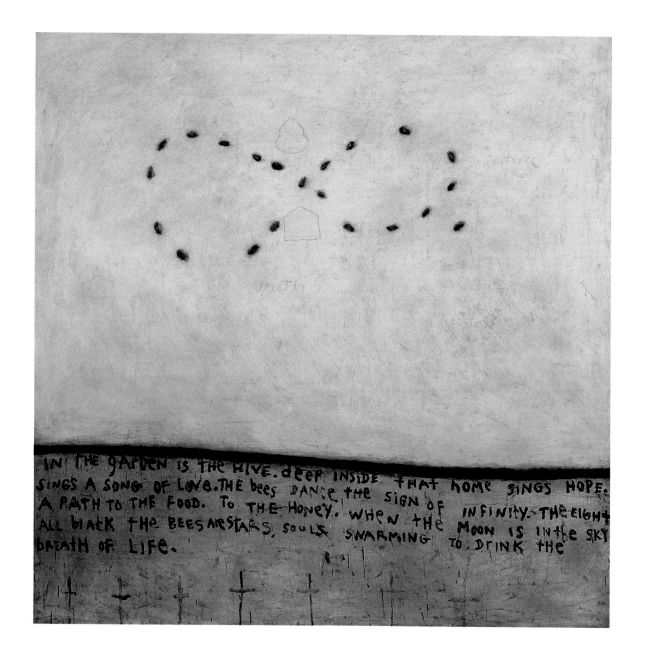

Day Song. 1988. Oil and alkyd on canvas, 82 x 82 inches. [Collection of Charlie Mitchell, Santa Barbara, California]

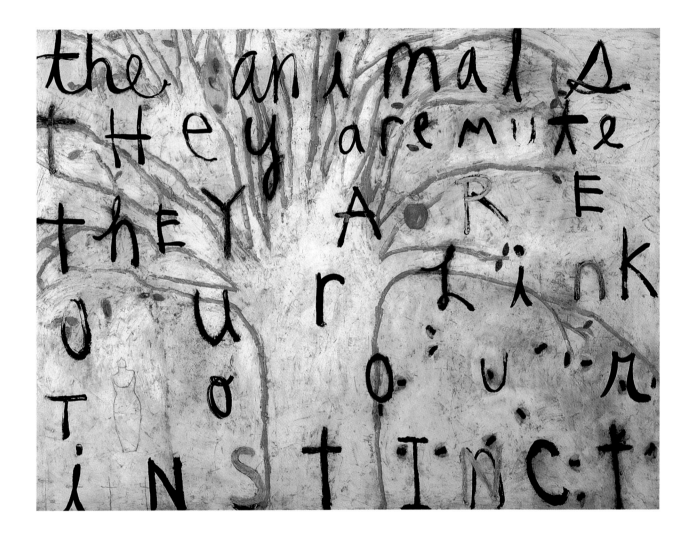

Animals. 1989. Oil and alkyd on canvas, 70 x 103 inches. [Collection of Squeak Carnwath and Gary Knecht]

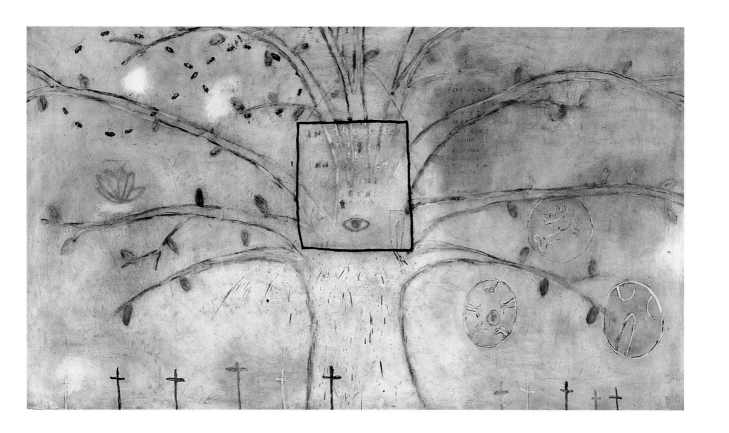

Inner Life. 1989. Oil, alkyd, and wax on canvas, 68 x 120 inches. [Collection of Palm Springs Desert Museum, gift of Steve Chase]

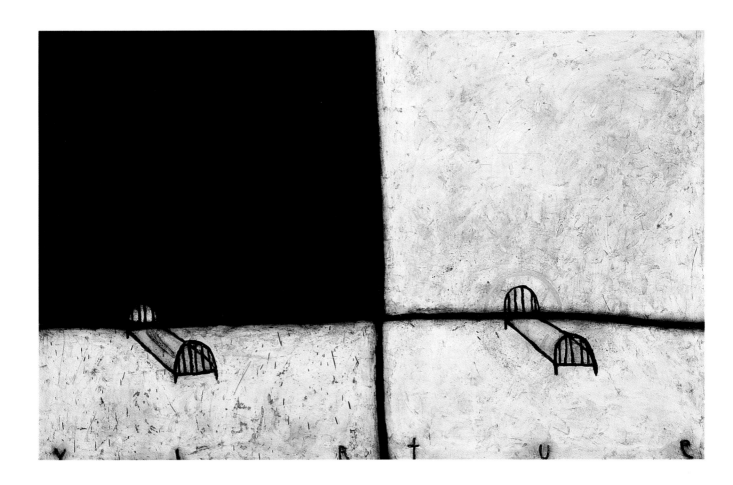

Virtue. 1989. Oil and alkyd on canvas, 68 x 108 inches. [Private collection, San Francisco, California]

Threshold, 1989. Oil and alkyd on canvas, 82 x 82 inches. [Collection of Boris Zerafa and Julie Frederickson, Toronto, Canada]

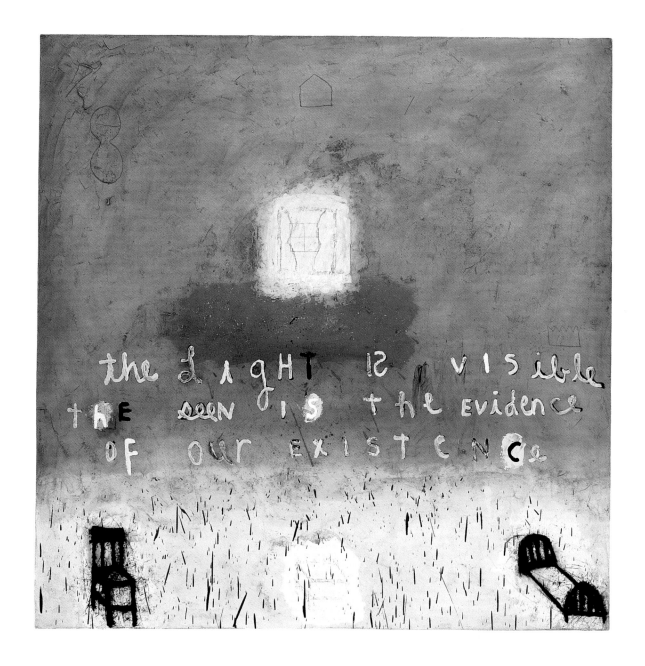

The Window. 1989. Oil and alkyd on canvas, 60 x 60 inches. [Collection of Charlie Mitchell, Santa Barbara, California]

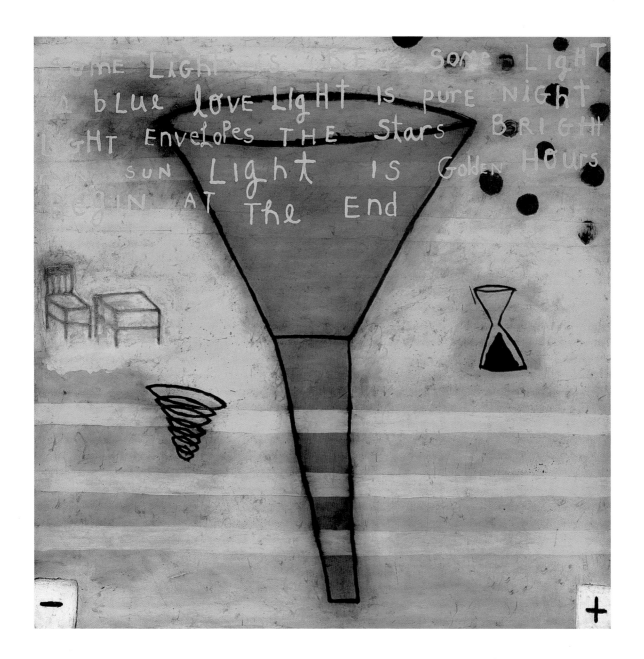

Mineral Light. 1989. Oil and alkyd on canvas, 70 x 70 inches. [Collecton of Laila Twigg-Smith, Honolulu, Hawaii]

Eating and Sleeping. 1990. Oil and alkyd on canvas, 71-1/2 x 71-1/2 inches. [Private collection]

Oh Say Can You See. 1990. Oil and alkyd on canvas, 60 x 60 inches. [Robert Borlenghi's "Collection '84— The Future of America," Dallas, Texas]

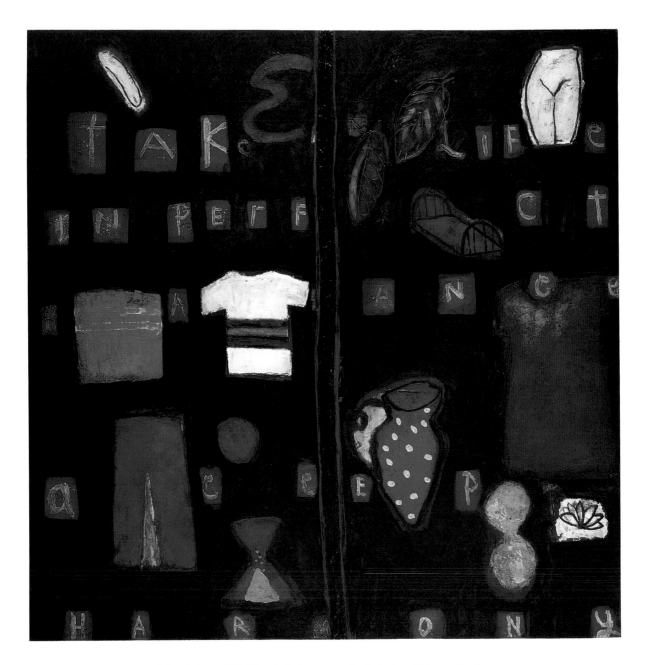

Anima Animus. 1990. Oil and alkyd on canvas, 82 x 82 inches. [Private collection]

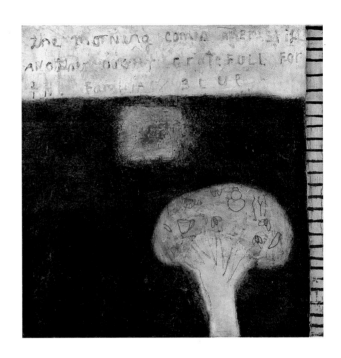

clockwise from top

Hope. 1990. Oil and alkyd on canvas, 20 x 20 inches. [Collection of Mark Winitsky, Los Angeles, California]

Blue. 1990. Oil and alkyd on canvas, 42 x 42 inches. [Collection of Leonard and Judith Gertler, Los Angeles, California]

1/2 Asleep. 1993. Oil and alkyd on canvas, 20 x 20 inches. [Private collection]

Mirror. 1990. Oil and alkyd on canvas, 70 x 210 inches (three panels). [Private collection]

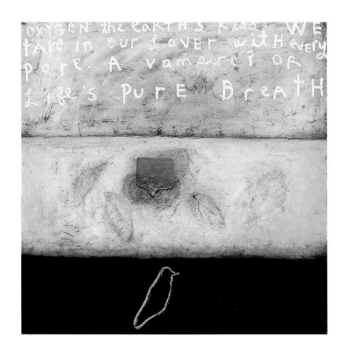

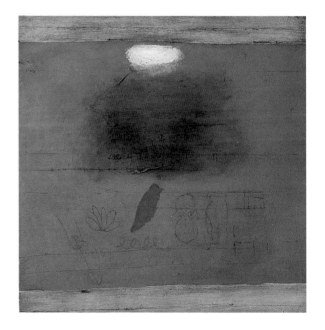

left **Canary. 1990**. Oil and alkyd on canvas, 36 x 36 inches. [Collection of Art Berliner, San Francisco, California]

right **Our Lives. 1990**. Oil and alkyd on canvas, 36 x 36 inches. [Private collection]

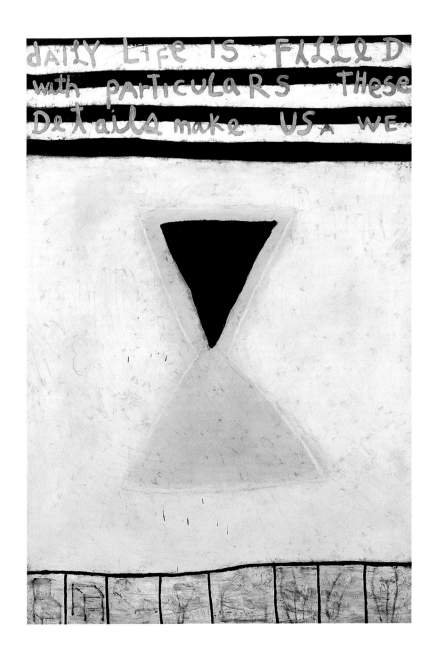

Certainty, 1990. Oil and alkyd on canvas, 94 x 64 inches. [Collection of Beth and Jeff Skelton]

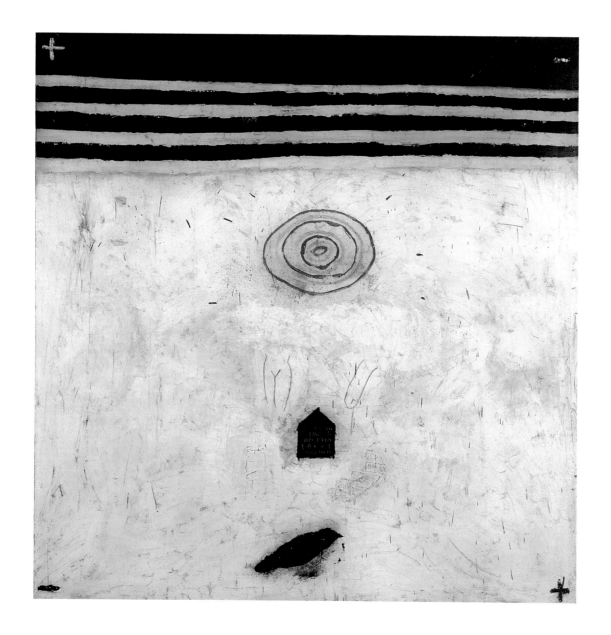

Home Safe, **1990**. Oil and alkyd on canvas, 77 x 75 inches. [Private collection]

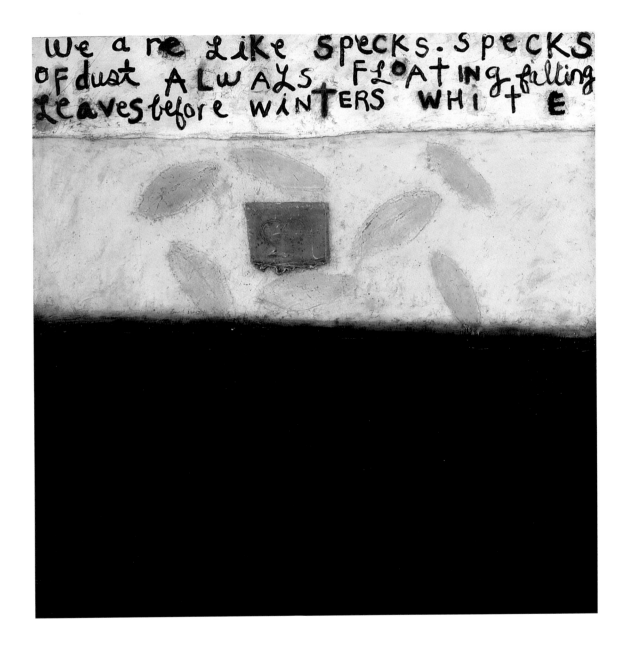

Specks. 1990. Oil and alkyd on canvas, 82 x 82 inches. [Collection of Squeak Carnwath and Gary Knecht]

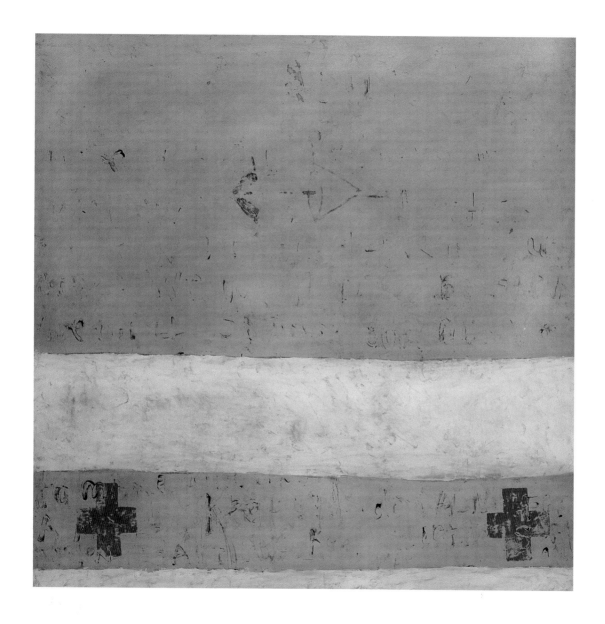

Listen. 1991. Oil and alkyd on canvas, 60 x 60 inches. [Mr. & Mrs. Sanford R. Robertson Collection]

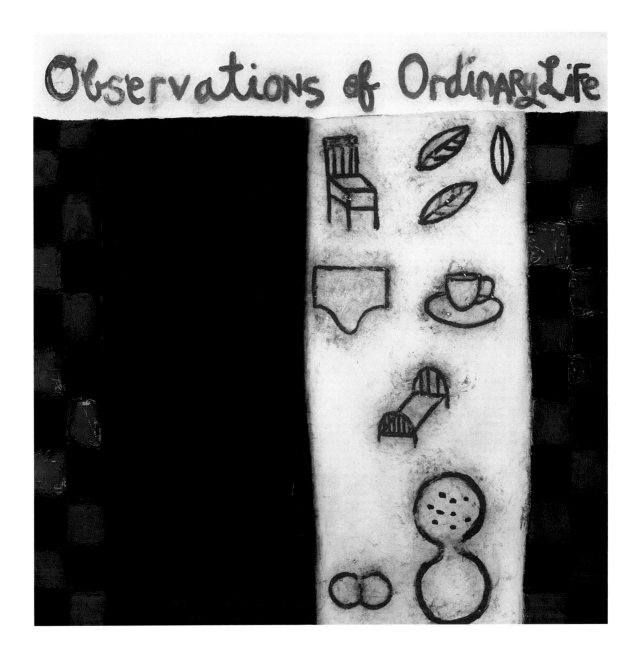

Simple. 1991. Oil and alkyd on canvas, 77 x 77 inches. [Private collection, San Diego, California]

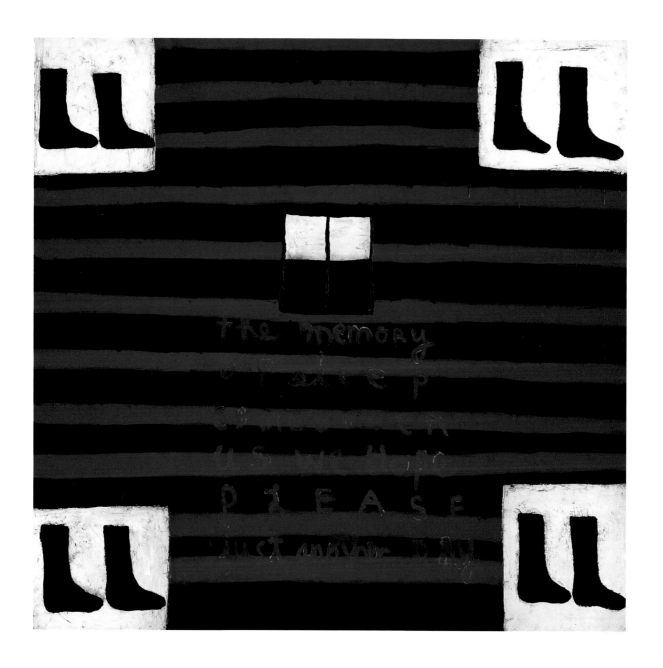

Memory, 1991. Oil and alkyd on canvas, 75 x 75 inches. [Collection of Gretchen and John Berggruen, San Francisco, California]

Miracle. 1992. Oil and alkyd on canvas, 82 x 82 inches. [Private collection, Oakland, California]

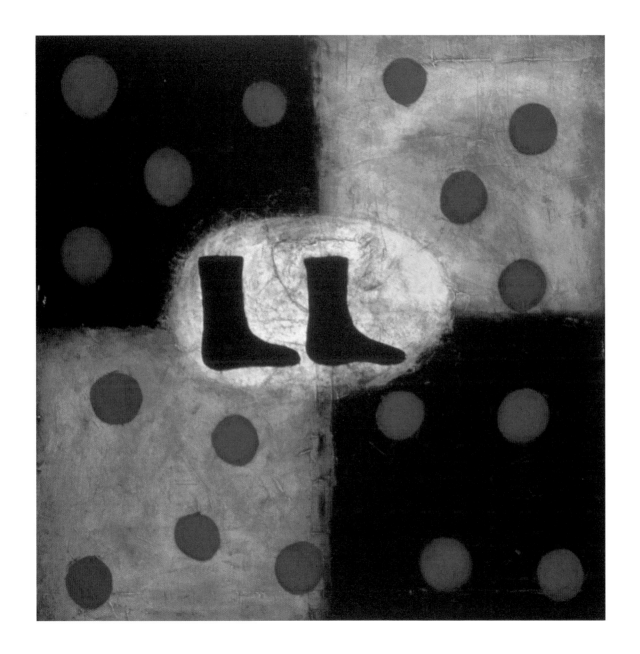

Giotto's Socks. 1991. Oil and alkyd on linen, 42 x 42 inches. [Collection of Bronson, Bronson & McKinnon, San Francisco, California]

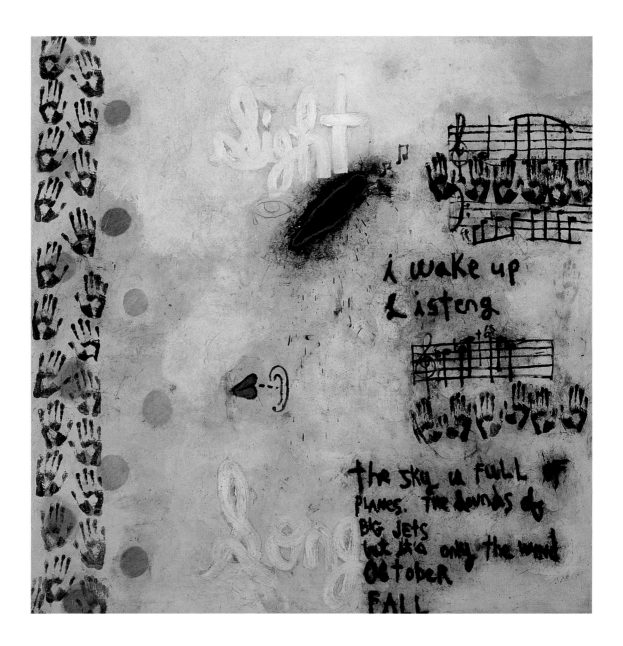

Sight Song. 1992. Oil and alkyd on canvas, 82 x 82 inches. [Private collection]

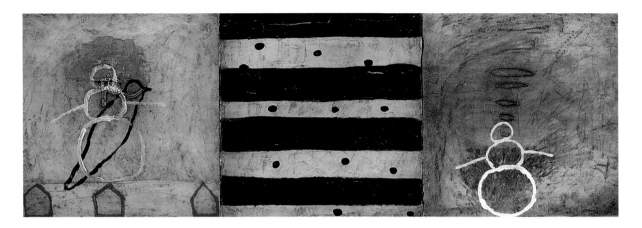

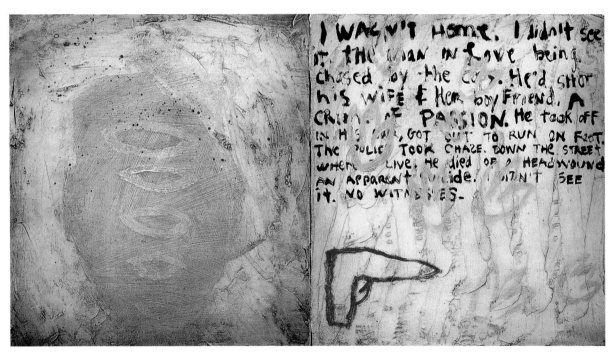

The text within the below image reads:

I WASN'T HOME. I DIDN'T SEE IT. THE MAN IN LOVE BEING CHASED BY THE COPS. HE'D SHOT HIS WIFE & HER BOYFRIEND. A CRIME OF PASSION. HE TOOK OFF IN HIS CAR, GOT OUT TO RUN ON FOOT. THE POLICE TOOK CHASE DOWN THE STREET WHERE I LIVE. HE DIED OF A HEADWOUND AN APPARENT SUICIDE. I DIDN'T SEE IT. NO WITNESSES.

above **Season and Pattern**, 1990. Oil and alkyd on wood, 15 x 45 inches (three panels). [Collection of Chuck and Kay Lowe, Dayton, Ohio]

below **The Man in Love—2**, 1990. Oil and alkyd on canvas, 13 x 24 inches (two panels). [Collection of the artist]

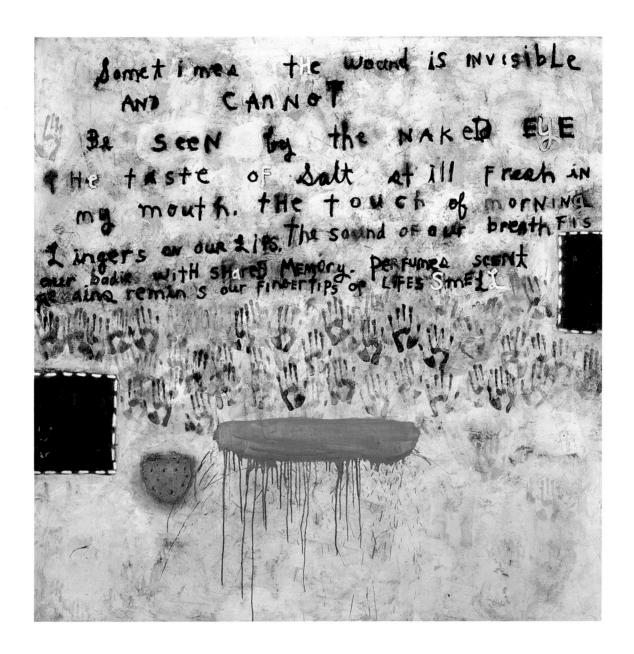

Senses, 1992. Oil and alkyd on canvas, 82 x 82 inches. [Collection of Esther and Bud Fischer]

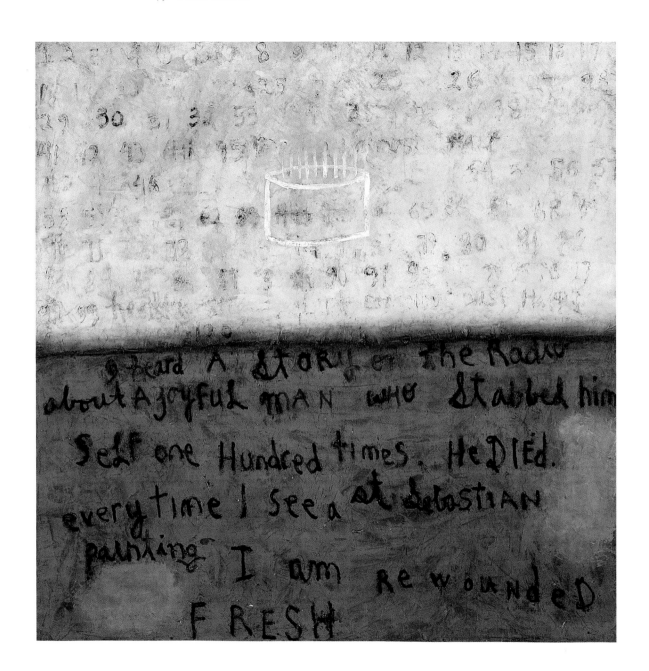

An Inability to Remain. 1992. Oil and alkyd on linen, 70 x 70 inches. [Private collection, Philadelphia, Pennsylvania]

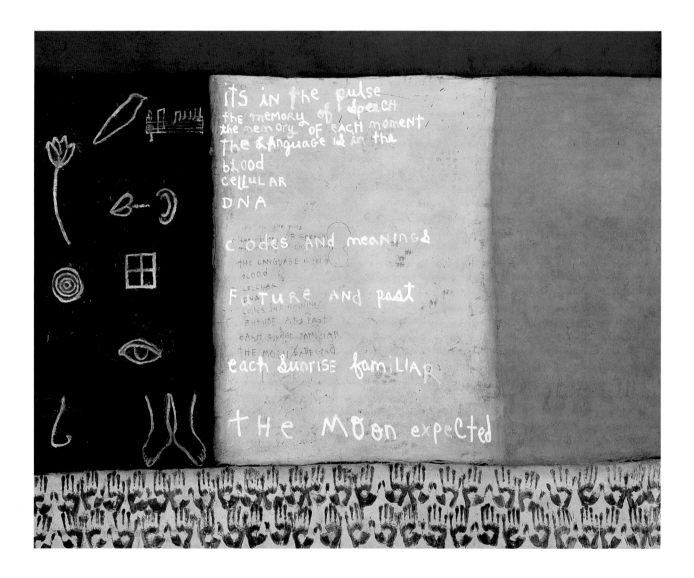

It Is In. 1992. Oil and alkyd on canvas, 82 x 103 inches. [Collection of Dr. and Mrs. Richard Golden, Grosse Point, Michigan]

Book of Days, 1992. Oil and alkyd on canvas, 82 x 82 inches. [Private collection]

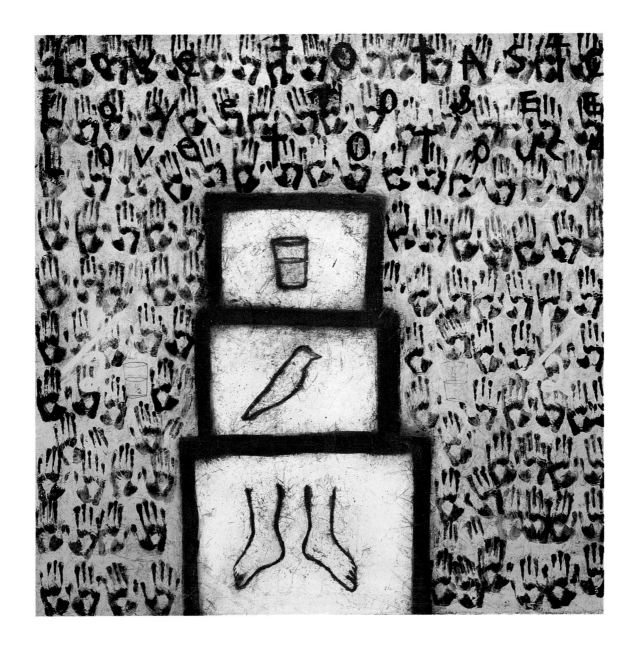

Attachments. 1993. Oil and alkyd on linen, 70 x 70 inches.

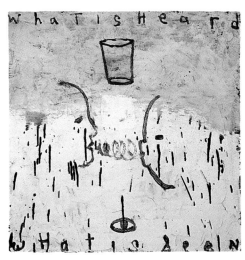

above **Halves Not Halves**, 1993. Oil and alkyd on canvas, 60 x 60 inches.

below **What Is Seen**, 1993. Oil and alkyd on panel, 20 x 20 inches. [Collection of Squeak Carnwath and Gary Knecht]

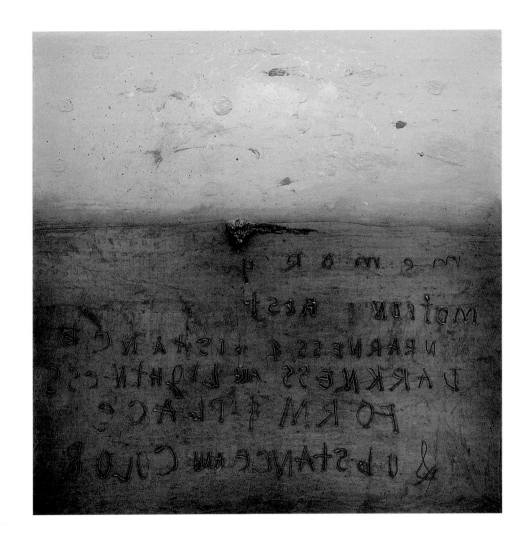

Leo's Memory, 1994. Oil and alkyd on board, 15 x 15 inches.

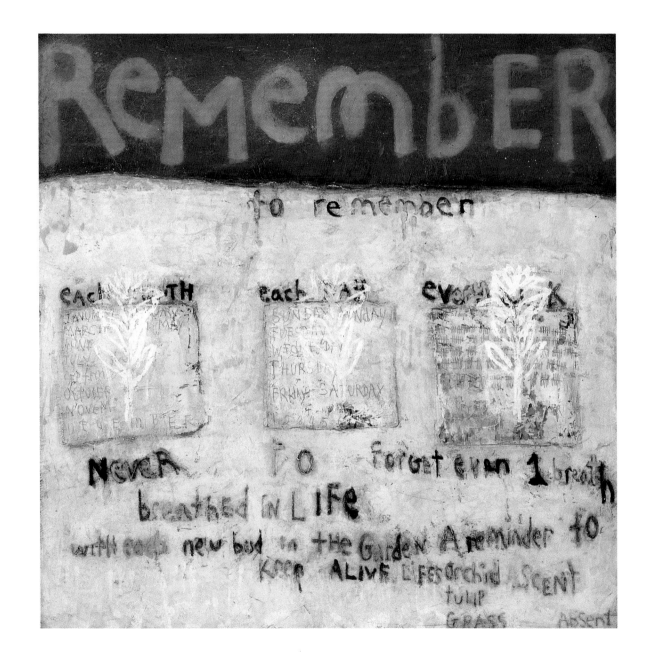

Don't Forget, **1994**. Oil and alkyd on canvas, 48 x 48 inches. [Private collection, San Francisco, California]

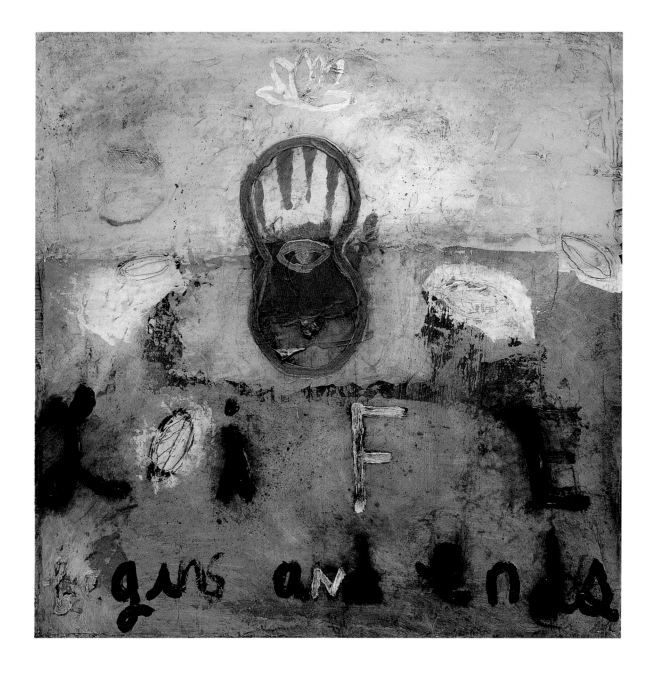

Begins. 1991. Oil and alkyd on canvas, 24 x 24 inches. [Private collection, San Francisco, California]

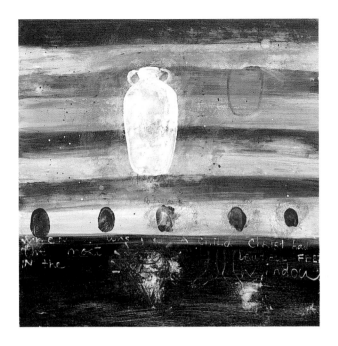

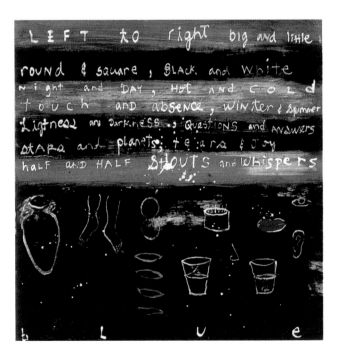

above **Feet in Window. 1994.** Egg tempera on birch wood, 11 x 11 inches. [Collection of Ted and Sidney Russell, San Francisco, California]

below **Left to Right. 1994.** Egg tempera on birch wood, 11 x 11 inches. [Collection of Mrs. Andy Williams, Branson, Missouri]

counting

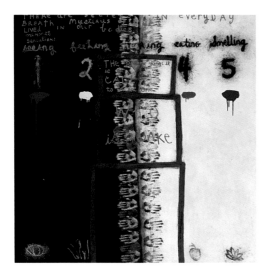

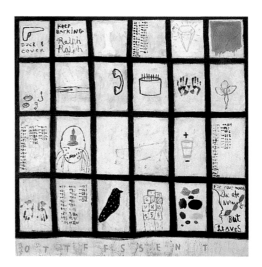

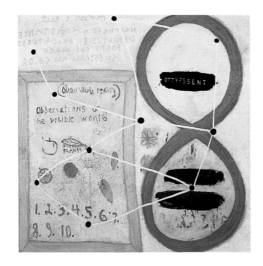

clockwise from top

Everyday Breath, **1992**. Oil and alkyd on canvas, 82 x 82 inches. [Collection of Squeak Carnwath and Gary Knecht]

Four Months, **1994**. Oil and alkyd on canvas, 80 x 80 inches.

Connections, **1994**. Oil and alkyd on linen, 70 x 70 inches. [Robertson, Stephens & Company Collection]

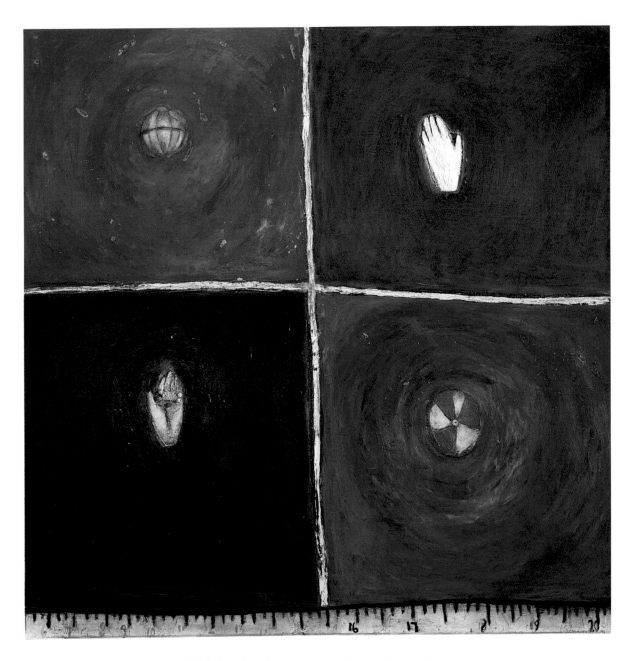

New Rule, **1987**. Oil and alkyd on canvas, 70 x 70 inches. [Private collection]

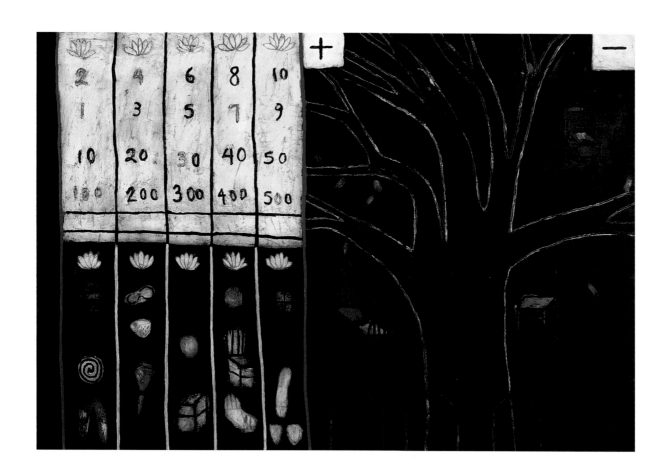

Math. 1989. Oil and alkyd on canvas, 64 x 94 inches. [Collection of Philip Morris Companies Inc., New York, New York]

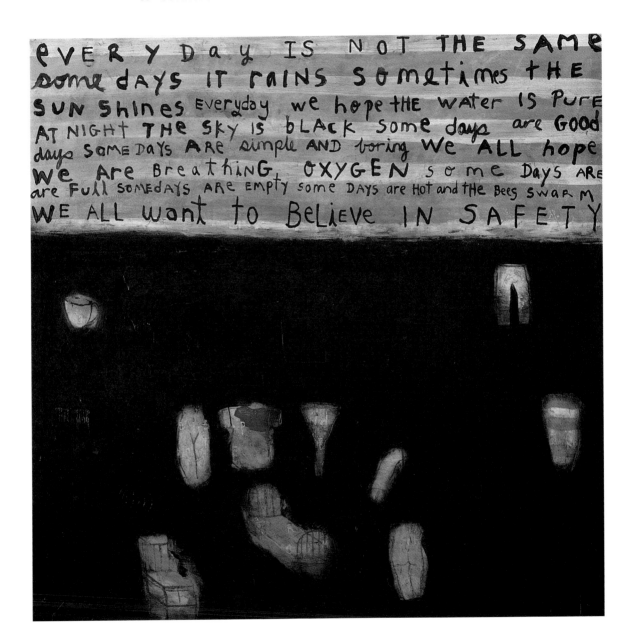

Daily Life. 1989. Oil and alkyd on canvas, 77 x 77 inches. [Collection of Ugo Sap, San Francisco, California]

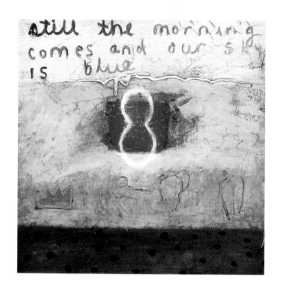

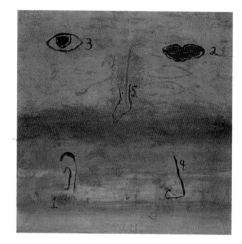

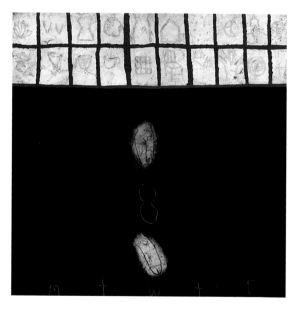

clockwise from top

Morning Blue. 1991. Oil and alkyd on canvas, 24 x 24 inches. [Collection of Robert and Judith Faust, Los Angeles, California]

Five. 1994. Oil and alkyd on wood, 9 x 9 inches. [Private collection]

Weekdays. 1991. Oil and alkyd on canvas, 36 x 36 inches.

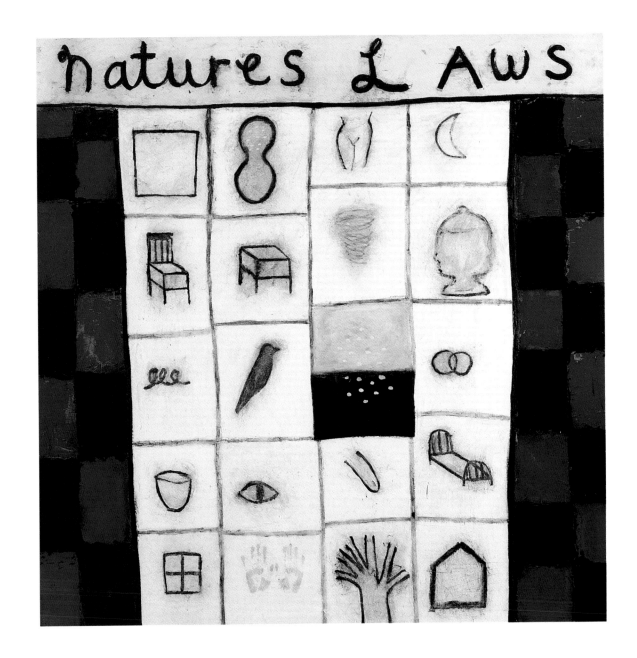

Different Pictures. 1991. Oil and alkyd on canvas, 82 x 82 inches. [Collection of Moses and Nafisa Taghioff, Fremont, California]

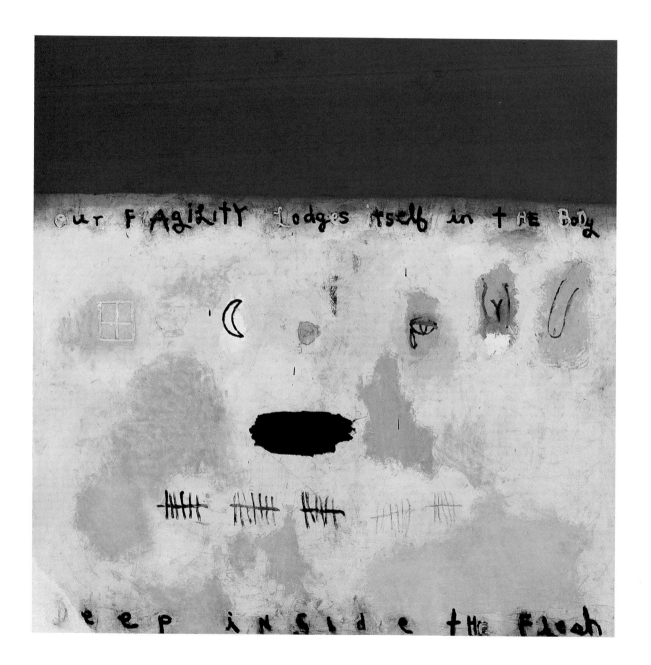

Fragile Thoughts. 1991. Oil and alkyd on canvas, 70 x 70 inches. [Collection of Allene Lapides, Santa Fe, New Mexico]

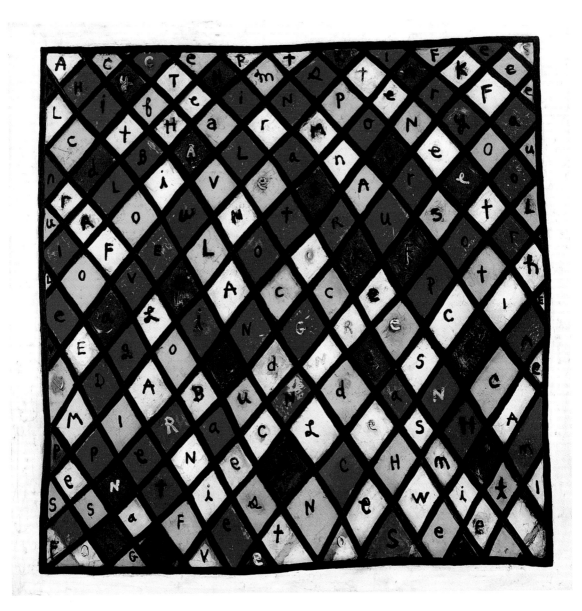

Message, 1991. Oil and alkyd on canvas, 82 x 82 inches. [Collection of the artist]

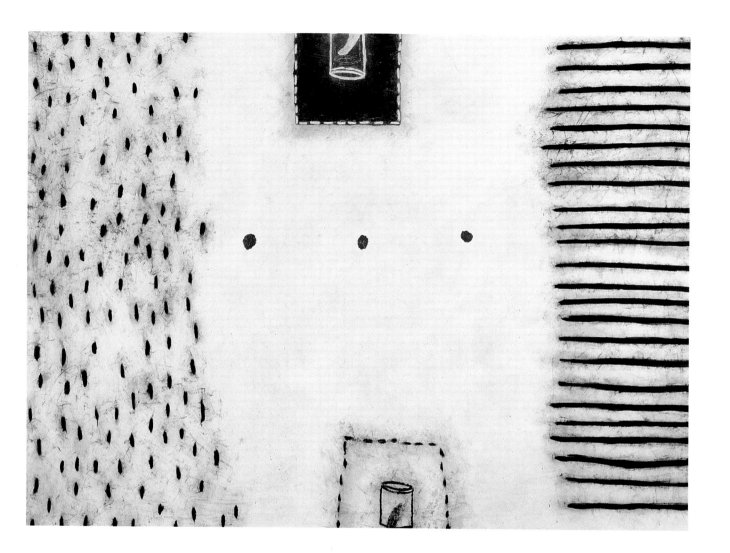

Science (Rain, Sound, Blood), 1992. Oil and alkyd on canvas, 80 x 110 inches. [Collection of the artist]

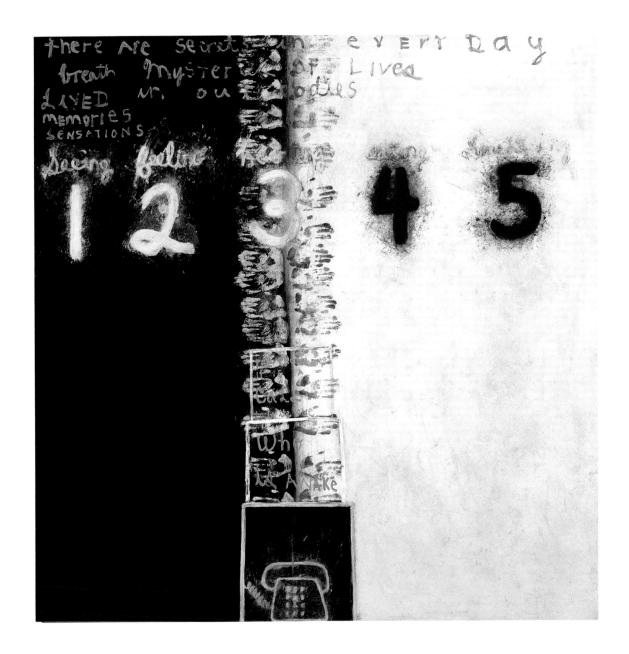

Mysteries (Lives Lived). 1992. Oil and alkyd on linen, 82 x 82 inches. [Private collection]

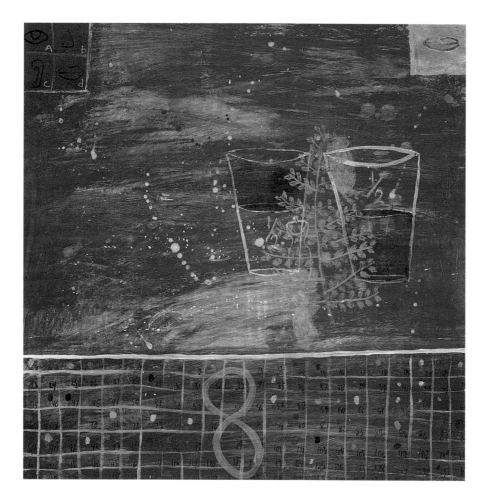

Two Waters and Fern, 1994. Egg tempera on birch wood, 15 x 15 inches. [Private collection]

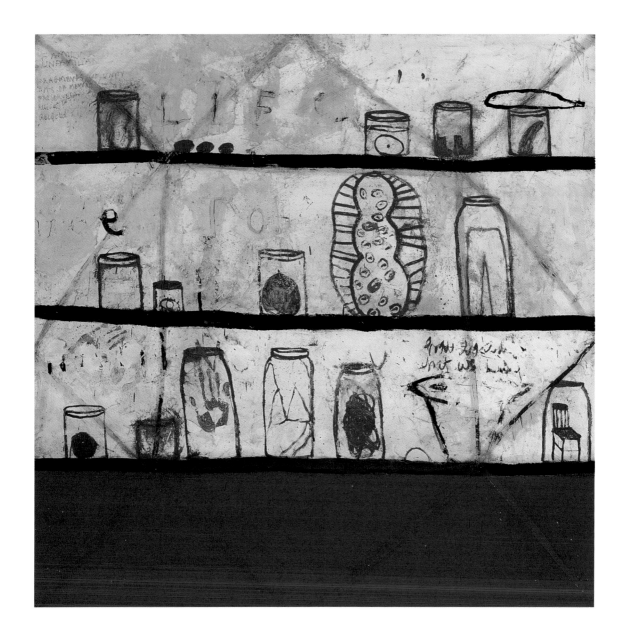

Collection. 1992. Oil and alkyd on linen, 60 x 60 inches. [Private collection, Los Angeles, California]

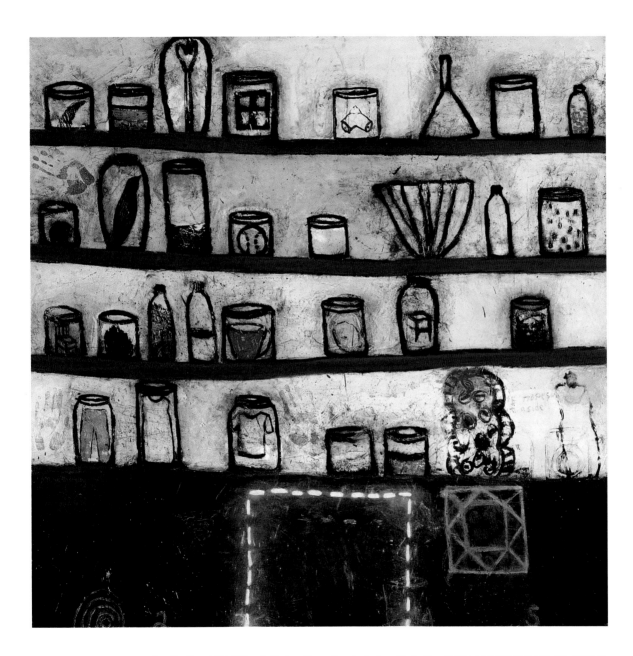

Recollection. **1992**. Oil and alkyd on linen, 60 x 60 inches. [Collection of Allene Lapides, Santa Fe, New Mexico]

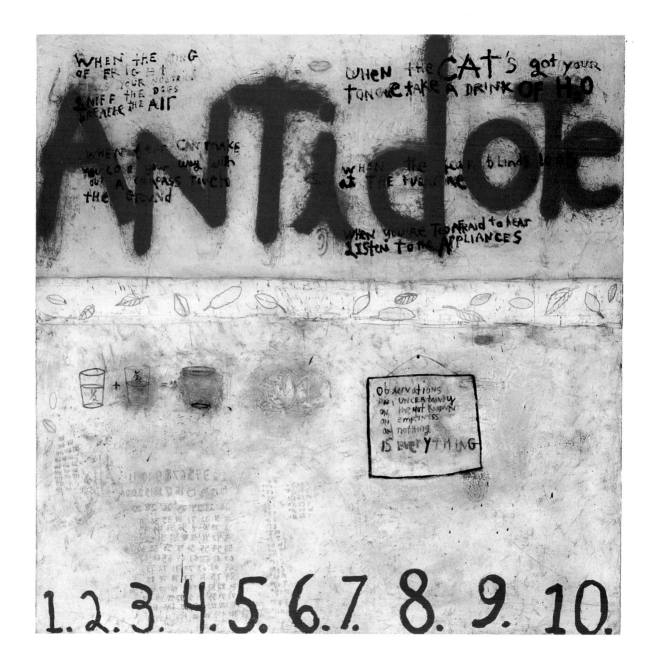

Remedy. 1993. Oil and alkyd on canvas, 70 x 70 inches. [Collection of Dr. Margaret E. Poscher, San Francisco, California]

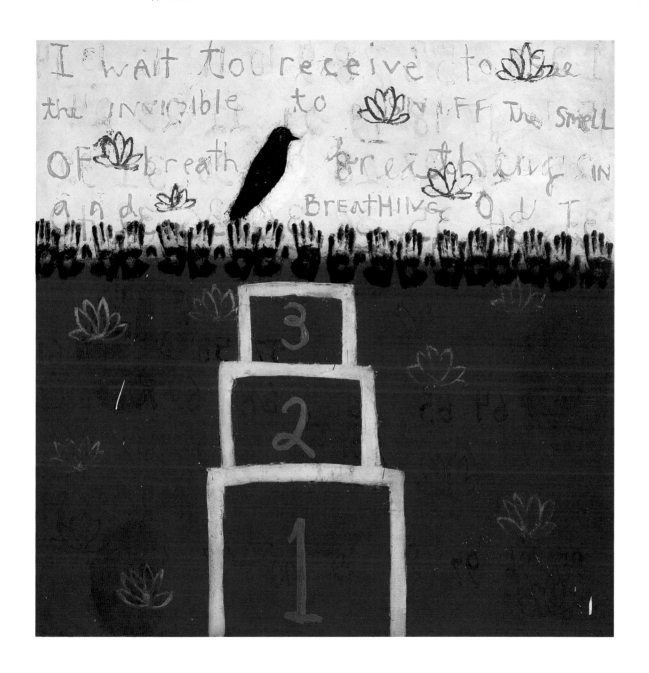

Second Wind. 1993. Oil and alkyd on linen, 70 x 70 inches. [Collection of Dr. Ellen Klutznick,
San Francisco, California]

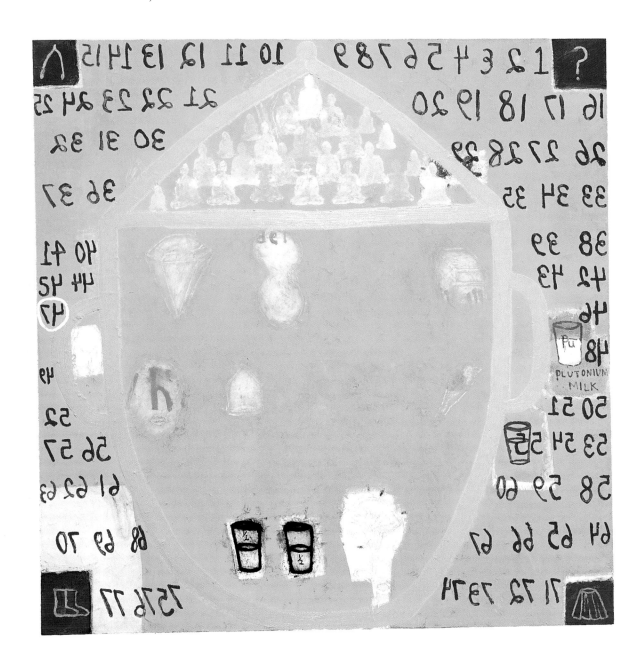

Inside Thought. 1994. Oil and alkyd on linen, 80 x 80 inches.

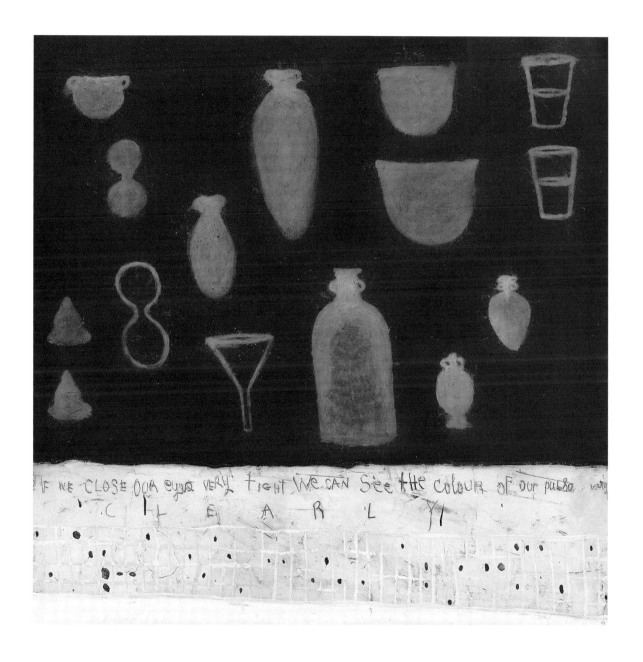

Pulse. 1994. Oil and alkyd on canvas, 48 x 48 inches. [Private collection, San Francisco, California]

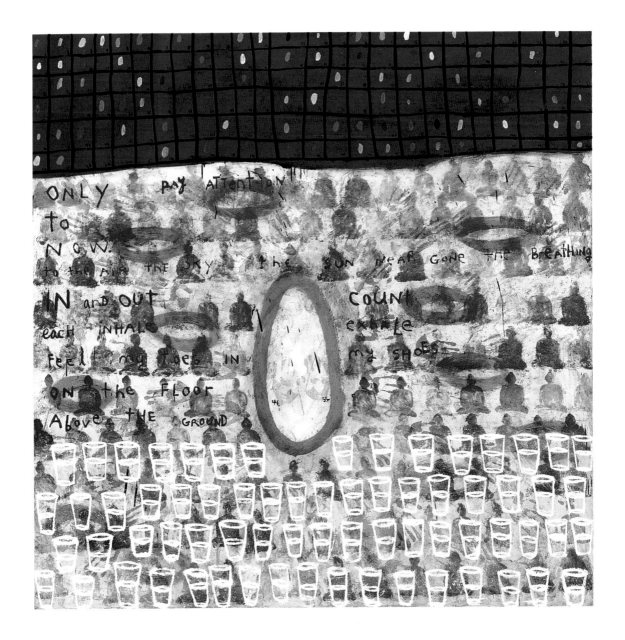

Between Sky and Ground. 1994. Oil and alkyd on canvas, 82 x 82 inches.

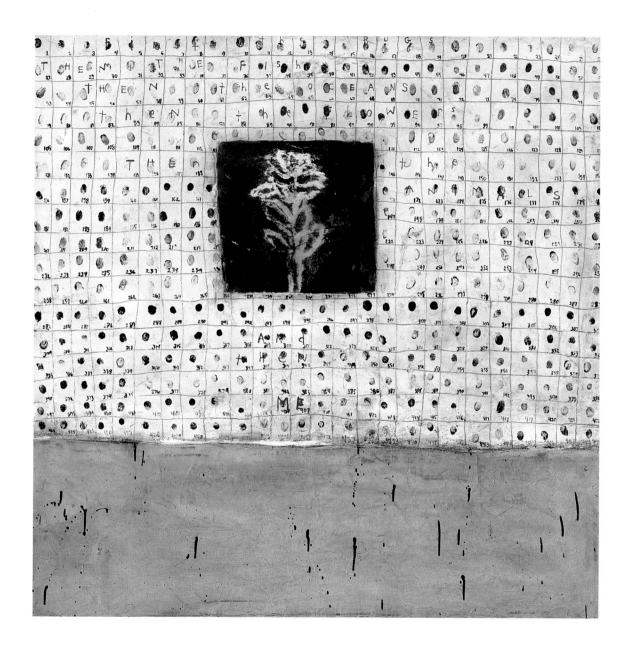

Precious Ocean. 1995. Oil and alkyd on canvas, 48 x 48 inches. [AirTouch Communications Collection, San Francisco, California]

Artist working on **Einstein's Brain Kansas**. 1995. Oil and alkyd on canvas, 82 x 82 inches.

chronology

1947
Born in Abington, PA, on May 24.

1948–64
Family frequently moved throughout the eastern seaboard (Plattsburg, NY; Port Kent, NY; Hanover, PA; Newton, MA; Marblehead, MA; Darien, CT; Syracuse, NY) and spent one year on the West Coast in Portland, OR.

1966
Graduated from Jenkintown High School, Jenkintown, PA.

1966–68
Attended and graduated from Monticello Junior College, Godfrey, IL.

1968
Attended summer program at Aegean School of Fine Arts in Paros, Greece, where she met Gary Knecht, a fellow student whom she would later marry.

1969–70
Studied at Goddard College, Plainfield, VT.

1970
Moved to California with Gary Knecht to attend California College of Arts and Crafts, Oakland, where she studied with Art Nelson and Viola Frey.

1971
Established studio in a commune in Oakland; participated in Food Conspiracy, a food-buying coop, in downtown Oakland.
Stopped attending classes in order to pursue art full time.
Rented a storefront and set up first solo exhibition at Roxie & Toots Salon d'Art.
Worked as shopmaster, Ceramics Department, California College of Arts and Crafts.

1975–77
Studied at California College of Arts and Crafts with Jay De Feo and Dennis Leon and again with Viola Frey. Graduated with M.F.A.

1977
Hired as CETA Community Artist by ArtWorks, a program of the Alameda County Neighborhood Arts Program.

1978
Father died.
Taught ceramics summer session at California College of Arts and Crafts.

1980
Received Visual Artists Fellowship grant from the National Endowment for the Arts.
Returned as shopmaster, Ceramics Department, California College of Arts and Crafts. Fired kilns and mixed glazes. Her two-year tenure allowed her to participate in an art community without the responsibilities of teaching and enabled her to establish an uninterrupted studio practice. She relinquished the position in 1982.
Received Society for Encouragement of Contemporary Art Award from San Francisco Museum of Modern Art, which included her first one-person museum exhibition, San Francisco Museum of Modern Art.
Began friendship and business relationship with Dorothy Goldeen at Hansen Fuller (later Hansen Fuller Goldeen and Fuller Goldeen) Gallery, San Francisco, CA. Her work continues to be represented by Dorothy Goldeen Gallery, Santa Monica, CA.

1982
Accepted first university teaching position, as one-year visiting faculty at University of California, Berkeley, where she met Elmer Bischoff and Joan Brown.

1983
Created first suite of intaglio prints at Teaberry Press, Oakland.
Joined the faculty at University of California, Davis, which at the time was distinguished by its dense concentration of Bay Area Funk and Figurative artists. Faculty included Wayne Thiebaud, Robert Arneson, Roland Petersen, Ralph Johnson, Mike Henderson, and Manuel Neri.

1985
Received Visual Artists Fellowship grant from the National Endowment for the Arts.

1987
Created first series of mixed-media prints at Magnolia Editions, Oakland.

1988
Joined John Berggruen Gallery, San Francisco, which continues to represent her work.

1989
Jay De Feo died.

1990
Received Alice Baber Art Award.

1991
Completed first series of monotypes at Experimental Workshop, San Francisco.
Created a series of monotypes during two-week artist residency at Anderson Ranch, Aspen, CO.

1992
Traveled the Piero della Francesca trail in Italy with Maria Olivieri Quinn. Then went to St. Petersburg, Russia, for group exhibition.
Traveled to Giverny, France, to study Monet's garden. Drove with Susan Martin to Colmar, France, to view Grunwald's Isenheim altarpiece.
Accepted four-week artist residency at Djerassi Foundation, Woodside, CA.
Art Nelson died.

1993
Spent two weeks in Paris, France, immersed in European art and architecture.
Took one-year leave of absence from University of California, Davis, to teach and be an associate dean at California College of Arts and Crafts.

1994
First traveling museum show, a seven-year survey exhibition curated by Trinkett Clark, opened at the Chrysler Museum, Norfolk, VA, and traveled to San Jose Museum of Art, San Jose, CA, and to The Contemporary Museum, Honolulu, HI.
Accepted invitation to participate as Artist-in-Residence at Pilchuck Glass School, Stanwood, WA.
Received a fellowship from the John Simon Guggenheim Memorial Foundation.
Took another one-year leave of absence from University of California, Davis, to work full time in studio.

1995
Returned to France to continue studies of art and architecture.
Completed leave of absence and returned to University of California, Davis, to resume teaching.

SELECTED SOLO EXHIBITIONS

1971 Salon D'Art, Oakland, CA

1975 Richmond Art Center, Richmond, CA

1978 San Francisco Art Commission Gallery, San Francisco, CA

1980 *Society for the Encouragement of Contemporary Art (SECA) Award 1980*, San Francisco Museum of Modern Art, San Francisco, CA*

1982 Hansen Fuller Goldeen Gallery, San Francisco, CA

1983 Palo Alto Cultural Center, Palo Alto, CA

Brentwood Gallery, St. Louis, MI

1984 Getler/Pall/Saper Gallery, New York, NY

Fuller Goldeen Gallery, San Francisco, CA

1985 Nelson Gallery, University of California, Davis, CA

Van Straaten Gallery, Chicago, IL

1986 Van Straaten Gallery, Chicago, IL

Fuller Goldeen Gallery, San Francisco, CA

1987 Gloria Luria Gallery, Miami, FL

Marilyn Butler Fine Art, Scottsdale, AZ

Davis Art Center, Davis, CA

1988 Fuller Gross Gallery, San Francisco, CA

1989 John Berggruen Gallery, San Francisco, CA

Dorothy Goldeen Gallery, Santa Monica, CA

Marilyn Butler Fine Art, Scottsdale, AZ

1990 Shea & Beker, New York, NY

Squeak Carnwath: Nature's Alchemy, San Diego State University Gallery, San Diego, CA

1991 Dorothy Goldeen Gallery, Santa Monica, CA*

John Berggruen Gallery, San Francisco, CA*

1992 *Squeak Carnwath: Recent Work*, Monterey Peninsula Museum of Art, Monterey, CA

Dorothy Goldeen Gallery, Santa Monica, CA

1993 LedisFlam Gallery, New York, NY

1994 Chrysler Museum, Norfolk, VA*

O.K. Harris/David Klein Gallery, Birmingham, MI

San Jose Museum of Art, San Jose, CA*

Dorothy Goldeen Gallery, Marina Del Rey, CA

John Berggruen Gallery, San Francisco, CA*

Cohen Berkowitz Gallery, Kansas City, MO

The Contemporary Museum, HI*

1995 Dorothy Goldeen Gallery, Santa Monica, CA

Equations: The Paintings of Squeak Carnwath, Bank of America World Headquarters, San Francisco, CA

Ohio University Art Gallery, Athens, OH

University Art Gallery, California State University, Stanislaus, Turlock, CA

*Exhibition catalog

SELECTED GROUP EXHIBITIONS

1972 Laguna Beach Museum of Art, Laguna Beach, CA

1973 Both-Up Gallery, Berkeley, CA

Richmond Art Center, Richmond, CA

Walnut Creek Civic Arts Gallery, Walnut Creek, CA*

1974 *Designer-Craftsman '74*, Richmond Art Center, Richmond, CA*

Ceramics and Glass, The Oakland Museum, Oakland, CA*

1976 California College of Arts and Crafts, Oakland, CA

Chabot College, Hayward, CA

1977 Security National Bank, Los Angeles, CA

Isabelle Percy West Gallery, California College of Arts and Crafts, Oakland, CA

1978 California College of Arts and Crafts, Oakland, CA

Three Installations, Capricorn Asunder, San Francisco Art Commission Gallery, San Francisco, CA

Mixed Media on Paper: 30 East Bay Women, Berkeley Art Center, Berkeley, CA*

1979 Diablo Valley College of Arts and Crafts, Pleasant Hill, CA

Northern California Clay Routes: Sculpture Now, San Francisco Museum of Modern Art, San Francisco, CA*

1980 Leah Levy Gallery, San Francisco, CA

The Peaceable Kingdom, Hansen Fuller Gallery, San Francisco, CA

1981 *Paintings*, University Galleries, California State University, Hayward, CA

The Figure: A Celebration, Art Museum of South Texas, Corpus Christi, TX (traveled to University of North Dakota Art Galleries, Grand Forks, ND)

1982 *C.C.A.C. 75th Anniversary Exhibition*, Richmond Art Center, Richmond, CA

From the Sunny Side, The Oakland Museum, Oakland, CA

Emerging Northern California Artists, Orange County Center for Contemporary Art, Santa Ana, CA

Pacific Current/Ceramics 1982, San Jose Museum of Art, San Jose, CA*

1983 *Prints: Coast to Coast*, Bruce Velick Gallery, San Francisco, CA

Bon à tirer, De Saisset Museum, University of Santa Clara, Santa Clara, CA

Elements Matter, Fuller Goldeen Gallery, San Francisco, CA

The Impolite Figure/New Figurative Painting by the Bay Area, Southern Exposure Gallery, San Francisco, CA*

de te Fabula Narratur, San Jose Institute of Contemporary Art, San Jose, CA

Resource/Reservoir, C.C.A.C.: 75 Years, San Francisco Museum of Modern Art, San Francisco, CA

1984 *San Francisco Bay Area Painting*, Sheldon Memorial Art Gallery, University of Nebraska, Lincoln, NB*

California, Bluxome Gallery, San Francisco, CA

Frumkin Struve Gallery, Chicago, IL

The Subject Is Object, Hearst Art Gallery, St. Mary's College, Moraga, CA

Bay Area Connection: Figure Painting 1984, Primary Colors, Carmichael, CA

Modern Romances, Resse Bullen Gallery, California State University Humbolt, Arcata, CA (traveled to San Jose Institute of Contemporary Art, San Jose, CA)

Introducing Six, Virginia Miller Gallery, Coconut Grove, FL

Stars, Fuller Goldeen Gallery, San Francisco, CA

Highlights: Selections from the Bank of America Corporation Art Collection, Bank of America World Headquarters, San Francisco, CA

1985 *The Peaceable Kingdom*, First Bank, Minneapolis, MN

The 20th Century: The San Francisco Museum of Modern Art Collection, San Francisco Museum of Modern Art, San Francisco, CA*

New Directions/California Painting 1985, Visual Art Center of Alaska, Anchorage (traveled throughout Alaska)*

1986 *70's into 80's: Printmaking Now*, Museum of Fine Arts, Boston, MA

Eccentric Drawing, Allan Frumkin Gallery, New York, NY

The Third Western States Biennial, Brooklyn Museum,
 Brooklyn, NY*
Van Straaten Gallery, Chicago, IL
Cal Collects, University Art Museum, University of
 California, Berkeley
Young American Artists IV, Mandeville Art Gallery,
 University of California, San Diego, La Jolla
1987 *Bay Area Artists: Small Works Invitational*, Janet
 Steinberg Gallery, San Francisco, CA
The Artists and the Myth, Monterey Peninsula Museum
 of Art, Monterey, CA
The House in Contemporary Art, University Art Gallery,
 California State University, Stanislaus, Turlock*
Diversity and Presence, University Art Gallery, University
 of California, Riverside (traveled)*
Viewing the Figure/Reflecting on the Self, Pritchard Art
 Gallery, University of Idaho, Moscow, ID
Four Bay Area Artists, Nancy Hoffman Gallery, New
 York, NY
Bay Area Drawing, Richmond Art Center,
 Richmond, CA*
Present Perspectives: 1975–1985, Fresno Arts Center and
 Museum, Fresno, CA
Under Currents, Portland Center for the Visual Arts,
 Portland, OR*
The Importance of Drawing, Fuller Goldeen Gallery,
 San Francisco, CA
1988 *Private Reserve*, Dorothy Goldeen Gallery, Santa
 Monica, CA
*Works on Paper: A Comprehensive Survey of Drawings
 and Watercolors*, John Berggruen Gallery, San
 Francisco, CA*
Selected Acquisitions, John Berggruen Gallery, San
 Francisco, CA
Twelve Artists, Triton Museum of Art, Santa Clara, CA
Professor's Choice III, Pomona College, Montgomery
 Gallery, Claremont, CA
Paintings and Sculpture by Candidates for Art Awards,
 American Academy and Institute of Arts and Letters,
 New York, NY
Narrative or Not, University Art Gallery, California State
 University at Hayward

1989 *Invitational Paintings*, Shea & Beker, New
 York, NY
Four California Artists, Fay Gold Gallery, Atlanta, GA
Substance and Surface, Else Gallery, California State
 University, Sacramento, CA
A.C.D.H.H.H.J.N.P.P.S.T., Nelson Gallery, Department
 of Art, University of California, Davis
Alice Through the Looking-Glass, Bernice Steinbaum
 Gallery, New York, NY*
1990 *Oakland Artists*, The Oakland Museum,
 Oakland, CA*
Woodblocks, Prints, Etchings, Dorothy Goldeen Gallery,
 Santa Monica, CA
The Painted Word, Richmond Art Center,
 Richmond, CA
Prints from Limestone, Simon James Gallery,
 Berkeley, CA
1991 *Herstory: Narrative Art by Contemporary
 California Artists*, The Oakland Museum,
 Oakland, CA*
Small Format Works on Paper, John Berggruen Gallery,
 San Francisco, CA
Large Scale Works on Paper, John Berggruen Gallery,
 San Francisco, CA*
Monochrome, Dorothy Goldeen Gallery, Santa
 Monica, CA
Professor's Choice, Lang Gallery, Scripps College,
 Galleries of the Claremont Colleges, Claremont, CA
Do You Hear What I'm Saying?, TransAmerica
 Building, San Francisco, CA
Freehand Drawing Loosely Defined, Euphrat Gallery,
 De Anza College, Cupertino, CA
1992 *ART CONTACT*, Central Exhibition Hall, St.
 Petersburg, Russia*
Fine Arts Presses, City Hall, Civic Center, San
 Francisco, CA
New Editions 1991–1992, Alice Simsar Gallery, Ann
 Arbor, MI
Contemporary Uses of Wax & Encaustic, Palo Alto
 Cultural Center, Palo Alto, CA
Professor's Choice, Pomona College, Claremont, CA
West Comes East, Ellen Miller/Katie Block Fine Art,
 Boston, MA

Voices, Shea & Bornstein, Santa Monica, CA
44th Annual Purchase Exhibition, American Academy
 and Institute of Arts and Letters, New York, NY
1993 *The Intimate Collaboration: Prints from
 Teaberry Press*, University Art Museum, Berkeley, CA
 (traveling)
Recent Acquisitions, John Berggruen Gallery,
 San Francisco, CA
1994 *Here and Now: Bay Area Masterworks from the
 di Rosa Collections*, The Oakland Museum,
 Oakland, CA*
American Art Today: Heads Only, The Art Museum at
 Florida International University, Miami, FL*
1995 *Old Glory, New Story: Flagging the 21st Century*,
 Capp Street Project, San Francisco, CA
Small Works, Stephen Haller Gallery, New York, NY
John Berggruen Gallery Twenty-five Years, John
 Berggruen Gallery, San Francisco, CA
Abstraction, The Bermuda National Gallery, Hamilton,
 Bermuda
*Exhibition catalog

PUBLIC AND
CORPORATE COLLECTIONS

BankAmerica Corporation Art Collection, San
 Francisco, CA
Benzinger Family Winery, Glen Ellen, CA
Brooklyn Museum, Brooklyn, NY
Chase Manhattan Bank, New York, NY
The Contemporary Museum, Honolulu, HI
The Jewish Museum San Francisco, San Francisco, CA
Richard L. Nelson Gallery and The Fine Arts Collection,
 University of California, Davis
The Oakland Museum, Oakland, CA
Palm Springs Desert Museum, Palm Springs, CA
Persis Corporation, Honolulu, HI
Philip Morris Companies, Inc., New York, NY
The Principal Financial Group, Des Moines, IA
Robertson, Stephens & Company, San Francisco, CA
San Francisco Museum of Modern Art, San
 Francisco, CA
University Art Museum, University of California,
 Berkeley

bibliography

SELECTED BOOKS AND EXHIBITION CATALOGS

Albright, Thomas. *Art in the San Francisco Bay Area, 1945–1980.* Berkeley and Los Angeles: University of California Press, 1985. P. 266.

Dorothy Goldeen Gallery. *Squeak Carnwath.* Essay by Mark Levy. Santa Monica: Dorothy Goldeen Gallery, 1991. 8 pp.

John Berggruen Gallery. *Squeak Carnwath.* San Francisco: John Berggruen Gallery, 1991. 8 plates.

John Berggruen Gallery. *Squeak Carnwath.* San Francisco: John Berggruen Gallery, 1994. 12 plates.

San Francisco Museum of Modern Art. *SECA Art Award 1980.* Sponsored by Society for the Encouragement of Contemporary Art (SECA) of the San Francisco Museum of Modern Art, 1980. Pp. 4–7.

The Chrysler Museum. *Squeak Carnwath.* Essay by Trinkett Clark. Norfolk: The Chrysler Museum, 1994. 8pp.

Walrod, Anne. "Squeak Carnwath" in Moira Roth, ed., *Connecting Conversations, Interviews with 28 Bay Area Women Artists.* Oakland: Eucalyptus Press, Mills College, 1988. Pp. 22–28

SELECTED ARTICLES, ESSAYS, AND REVIEWS

Ahlander, Leslie Judd. "Abstract Ideas and Landscapes Populate the Galleries." *Miami News,* December 18, 1987.

Albers, Patricia. "Deeper by the Dozen." *San Jose Metro,* October 6–12, 1988, p. 16.

Albright, Thomas. "Arts Festival Pizza and Quiche." *San Francisco Chronicle,* June 25, 1983, p. 35.

_____. "Emerging, Diverging and Submerging at Oakland Museum." *San Francisco Chronicle,* October 26, 1982, p. 40.

_____. "Imagism and a New Look." *San Francisco Chronicle,* March 8, 1982, p. 40.

_____. "Landscapes & Figures: Distant from Reality." *San Francisco Chronicle,* July 17, 1984, pp. 12–13.

_____. "Modest Magic, Conventionalized Personalism." *San Francisco Chronicle,* September 1, 1980, p. 41.

Allman, Paul. "Art Who?" *New Vistas,* February 15, 1975, p. 14.

Anderson, Roger. "Oaklandish Art." *East Bay Express,* June 22, 1990.

"Art at UCD." *UC Davis Magazine,* Summer 1988.

"Artists Paint Own Views of California." *Anchorage Times,* September 22, 1985.

Artner, Alan G. "Carnwath's Canvases Reflect Classic Looks at Domestic Life." *Chicago Tribune,* March 8, 1985, p. 38.

Baker, Kenneth. "Childhood Whimsy in 'Mouse' Art." *San Francisco Chronicle,* September 17, 1988.

_____. "Squeak Carnwath Roars at Berggruen." *San Francisco Chronicle,* September 21, 1989, p. E5.

_____. "Squeak Carnwath's Interplay of Words and Images." *San Francisco Chronicle,* September 11, 1991, p. E2

Balken, Debra Bricker. "Squeak Carnwath at LedisFlam." *Art in America,* February 1994, pp. 103–104.

Boettger, Suzaan. "From the Sunny Side: Six East Bay Artists." *Artforum,* January 1983, pp. 82–83.

_____. "The Human Condition: Biennial III, San Francisco Museum of Modern Art." *Artforum,* October 1984, pp. 96–97.

_____. "The Impolite Figure." *Artforum,* October 1983, p. 81.

Bonetti, David. "Exhibitions Focus on Artists' Visions of '70s." *San Francisco Examiner,* September 16, 1994, pp. D8–D9.

Bouras, Harry. "Carnwath at van Straaten Gallery." *WFMT, Chicago,* October 17, 1986.

Brenson, Michael. "How the Myths and Violence of the West Inspire Its Artists." *New York Times,* June 15, 1986.

Breslin, Ramsay Bell. "Those Who Forget Her Story." *East Bay Express,* February 8, 1991, p. 30.

Brookman, Donna. "A Bay Area Diversity." *Artweek,* October 15, 1988.

Brown, Betty Ann. "Songs of the Bees." *Artweek,* March 11, 1989, p. 5.

Brzezinski, Jamey. "Enigmatic Extremities: Squeak Carnwath at John Berggruen Gallery." *Artweek,* September 26, 1991, p. 11.

Burkhart, Dorothy. "Promising Futures." *San Jose Mercury News,* July 17, 1988.

Burstein, Joanne. "From the Sunny Side: Six East Bay Artists." *Artweek,* October 23, 1982, p. 1.

Butterfield, David. "National Recognition for Alameda Artist." *Alameda Times-Star,* November 10, 1980, p. 3.

"Carnwath Exhibition." *Ceramics Monthly,* February 1978, pp. 83–85.

Cebulski, Frank. "Ghosts, Textures and Sound." *Artweek,* September 20, 1980, p. 3.

Colby, Joy Hakanson. "Symbolism Figures Big in these Artists' Visions." *Detroit News,* May 13, 1994, p. 4D.

Cook, Katherine. "Language Into Image, The Painted Word at Richmond Art Center." *Artweek,* September 6, 1990.

Cotter, Holland. "Art in Review: Squeak Carnwath at LedisFlam Gallery." *New York Times,* September 17, 1993, p. C18.

Curtis, Cathy. "Looking for Romance." *Artweek,* March 3, 984, pp. 5–6.

Cutajar, Mario. "Squeak Carnwath." *ArtScene,* Vol. 12, No. 4, December 1992, p. 18.

Degener, Patricia. "Exhibits at Three Galleries." *St. Louis Post-Dispatch,* June 22, 1983, p. D7.

Deragon, Rick. "Artists' Day." *Monterey County Herald,* September 25, 1992, p. 3D.

Diehl, Carol. "Squeak Carnwath, LedisFlam." *ARTnews,* December 1993, pp. 133–132.

Eaton, Kate Regan. "Work/Live: They Work and Live Together." *Oakland Artscape,* Fall/Winter 1992, p. 5.

Edelman, Robert G. "Squeak Carnwath." *Art Press 185,* November 1993, p. 85.

Engelfried, Sally. "Painter Squeak Carnwath Speaks Up About Art, Feminism, and Real Time." *510 Magazine,* December 1994, pp. 35–36.

Fowler, Carol. "Some Objects Larger Than Life in Hearst Gallery Exhibition." *Contra Costa Times,* March 26, 1984, p. 11A.

Frankenstein, Alfred. "Serene and Mystic Art Works." *San Francisco Chronicle,* November 17, 1978, p. 68.

Garrison, Jayne. "When Slums Get Hip, Artists Move On—or Buy." *San Francisco Examiner,* 1985.

Green, Roger. "Dollars, Cowboys and Liberty at CAC." *New Orleans Times Picayune,* November 14, 1986.

Henry, Gerrit. "Squeak Carnwath at Shea & Beker." *Art in America,* October 1990, pp. 211–212.

Johnson, Mark M. "Western States Art." *Arts & Activities*, November 1986.

Kandel, Susan. "L.A. in Review, Squeak Carnwath." *Arts Magazine*, Summer 1989, p. 104.

Ketcham, Diane. "Squeak's Free-wheeling Style." *Oakland Tribune*, September 15, 1991, p. 11.

Lee, Anthony W. "Squeak Carnwath." *Art of California*, Spring 1991, pp. 50–54.

Levy, Mark. "Squeak Carnwath, Reclaiming Lost Territory." *Artspace*, January/February 1990, pp. 35–39.

Loughery, John. "Bay Area Artists, Nancy Hoffman Gallery." *Arts Magazine*, September 1987.

M., K. "The Galleries–Santa Monica." *Los Angeles Times*, February 24, 1989.

Manoogian, Bridget. "Reconstructing Carnwath." *Shift X*, 1990, pp. 16–18.

Matthews, Lydia. "Stories History Didn't Tell Us." *Artweek*, February 14, 1991, pp. 15–16.

McCloud, John. "Not Boxed In." *SF, The Magazine of Design and Style*, May 1991, pp. 100–105.

McCloud, Mac. "Patinae and Pentimenti: Paintings as Palimpsests in Santa Monica." *Visions Art Quarterly*, Spring 1991, p. 36.

McDonald, Robert. "Five Young Artists' View of the Human Condition." *Los Angeles Times*, February 22, 1986.

McGovern, Adam. "Summer Group Show: Prints & Works on Paper: Shea & Beker." *Cover*, September 1990.

Miro, Marsha. "Artists' Paintings Share Childlike Vision." *Detroit Free Press*, May 24, 1994, p. 9.

Mochary, Alexandra. "Bay Area Art: Take Another Look." *Antiques & Fine Art*, November 1987, pp. 71–75.

Nadaner, Dan. "What Only Painting Can Do." *Artweek*, January 25, 1986, p. 3.

Newhall, Edith. "Galleries." *New York Magazine*, September 13, 1993, pp. 58, 60, 63.

Ollman, Leah. "Wonder of Life Bathes Carnwath's Canvases." *Los Angeles Times*, May 1990.

Paul, James. "Other Side of the Bay." *Washington Post*, February 28, 1986.

Pincus, Robert L. "Artist Masters Mix of Visual, Literary." *San Diego Union*, May 1, 1990.

_____. "The Brave and the Foolhardy Wade into Surrealism." *San Diego Union*, February 27, 1986.

Preston, Jane. "Media at Walnut Creek." *Artweek*, November 24, 1973, p. 5.

Pund III, Ernest E. "Young American IV Opens at Mandeville." *La Jolla Light*, February 13, 1986.

Raynor, Vivien. "Four Bay Area Artists." *New York Times*, July 10, 1987.

Roder, Sylvie. "Tales Old and New." *Artweek*, June 4, 1983, p. 5.

Rose, Joan. "Sensuous Exhibits at Contemporary Museum." *Honolulu Advertiser*, November 20, 1994, p. G10.

Rubin, Michael G. "2 Contrasting Artists Rising in Prominence." *St. Louis Globe-Democrat*, June 25–26, 1983, p. 6F.

Scarborough, James. "Squeak Carnwath at Hansen Fuller Goldeen Gallery." *Artweek*, March 20, 1982.

Shere, Charles. "Born Innocent: Artist's Style Matures." *Oakland Tribune*, January 21, 1986.

_____. "A Handsome Showing in Various Media at S.F. Galleries." *Oakland Tribune*, September 30, 1980, p. C9.

_____. "Lot of Glitter, Little Gold at L.A. Art Fair." *Oakland Tribune*, December 1, 1986.

_____. "Painting Worth Looking At." *Oakland Tribune*, October 10, 1982, p. H6.

_____. "Richmond's B.A.D. Show Is Good." *Oakland Tribune*, July 7, 1987.

"Show Does Well at Representing California." *Anchorage Daily News*, September 22, 1985.

"Squeak Carnwath, Fuller Goldeen Gallery." *Artforum*, June 1984, p. 98.

"Squeak Carnwath, Shea & Beker," *Cover*, April 1990, p. 17.

"Squeak Carnwath at van Straaten Gallery." *Art Now/ New York Gallery Guide*, February 1985.

"Squeak Speaks." *Portfolio Magazine*, January 18, 1994, p. 15.

Swift, Harriet. "Making 'Her Story.'" *Oakland Tribune*, 1991.

Tamblyn, Christine. "Squeak Carnwath/John Berggruen." *ARTnews*, December 1989, p. 174.

Thym, Jolene. "You Can't Ignore Her Playful Works of Art." *Oakland Tribune*, April 22, 1994, p. CUE-8.

_____. "Making a Spectacle." *Oakland Tribune*, March 12, 1994, p. CUE-1.

Van Proyen, Mark. "Perceptions of Self & Native." *Artweek*, January 30, 1988.

_____. "Rampant Diversity, Something for Everyone is Thesis of Oakland's Artists '90 Show." *Artweek*, December 18, 1990.

Van Proyen, Mark, and Phyllis Shafer. "Squeak Carnwath, Excerpts from an Interview with Mark Van Proyen & Phyllis Shafer." *Expose*, January/February 1984, pp. 10–14.

Welles, Edward O. "To Market, to Market, to Buy a Franz Kline." *San Jose Mercury News*, March 29, 1987.

Whittaker, Richard. "A Conversation with Squeak Carnwath." *TSA [The Secret Alameda]*, Issue #6, 1993, pp. 2–8.

Winn, Steven. "Ramps and Ghosts." *ARTnews*, January 1981, pp. 77–78.

Wojtas, Thomas. "Michigan: Squeak Carnwath at David Klein Gallery." *New Art Examiner*, April 1995.

Wolf, Theodore F. "Western Art." *Christian Science Monitor*, June 30, 1986.

"Works from the di Rosa Collection at The Oakland Museum." *Gallery Guide—International*, November 1993, p. WC51.

Wright, Jeff. "Squeak Carnwath: Shea & Beker" *Cover Magazine*, April 1990.

acknowledgments

This book came about through a series of lucky events and the hard work and generosity of many people. To all those who believe in my work, I owe an enormous debt of gratitude. Special thanks to:

Gary Knecht, for his tireless dedication to detail and his ability to priortize the many tasks of building this book.

Pauline Shaver, for her inspiring cheerfulness and dogged hard work. Her enthusiastic help gave me the invaluable gift of time in the studio.

Gretchen and *John Berggruen* of John Berggruen Gallery in San Francisco, two special people whose friendship is evidenced by their unflinching dedication to my work and their gracious willingness to accept each new path my art takes. It was through John's efforts that Chronicle Books initially took an interest in this project.

Dorothy Goldeen of Dorothy Goldeen Gallery in Santa Monica, whose friendship and steadfast loyalty I value and whose galleries have regularly exhibited my work since 1980.

Byron Cohen of Cohen Berkowitz Gallery in Kansas City, whose ardent support of my work is a great source of delight and comfort.

Trinkett Clark, a curator who listens to her own heart and follows the instincts of her eyes and intelligent mind, for her significant recognition of my work.

Lee Fatherree, who has beautifully and sensitively photographed my work since 1977.

Nion McEvoy and *Charlotte Stone* of Chronicle Books, who persisted in their belief in the book.

The *John Simon Guggenheim Memorial Foundation,* for the fellowship that gave me the time to devote to my studio practice.

The *University of California, Davis,* for granting me a leave of absence to pursue my research during this fellowship year.

Leah Levy, for her discerning observations and years of familiarity with my art.

Ramsay Bell Breslin and *James E. B. Breslin,* for their sensitivity to the subtle nature of the paintings' voice and for asking provocative questions. I enjoyed answering.

Susan Martin, for her abiding respect for studio practice.

Jane Rosen, for her intelligent advice on what to say.

Charles Fiske, for his confidence and trust.

And, *Viola Frey,* my dear friend and colleague who shepherded me as a student, later recognized me as an equal, and has gifted me with a true and loyal friendship.